LIVING MAPS

AN ATLAS OF CITIES PERSONIFIED

ADAM DANT

CHRONICLE BOOKS

SAN FRANCISCO

Library of Congress Cataloging-in-Publication Data

Names: Dant, Adam, artist.

Title: Living maps : an atlas of cities personified / by Adam Dant.
Description: San Francisco : Chronicle Books, 2018.
Identifiers: LCCN 2017058270 | ISBN 9781452149523 (hardcover)
Subjects: LCSH: English wit and humor, Pictorial. | Cities and towns —
Caricatures and cartoons. | Satirical maps.
Classification: LCC NC1479.D26 A4 2018 | DDC 700/.41 — dc23 LC record
available at https://lccn.loc.gov/2017058270

ISBN: 978-1-4521-4952-3

Manufactured in China.

Designed by Brooke Johnson

10 9 8 7 6 5 4 3 2 1

Chronicle books and gifts are available at special quantity discounts to corpora-
tions, professional associations, literacy programs, and other organizations. For
details and discount information, please contact our premiums department at
corporatesales@chroniclebooks.com or at 1-800-759-0190.

Chronicle Books LLC
680 Second Street
San Francisco, California 94107
www.chroniclebooks.com

CONTENTS

JERUSALEM
The City Perpetually Conquered
8

MECCA
The City as the Center
of Attention
12

ROME
The Extra-Limbed City
16

VENICE
The City as the Mouth
of the Country
20

ISTANBUL
The Nerves of the City
24

PARIS
The Bones of Liberty
28

ZURICH
The Mouth of Hell
32

MOSCOW
The City Out of Reach
36

COPENHAGEN
Fairy-Tale Cities
40

AMSTERDAM
The Ever-Expanding City
44

EDINBURGH
The Old City Carries the New
48

LONDON
The City Digested
52

LONDON
The City Squared
56

THE CITY OF LONDON
The City's Founders
60

MONACO
The City as Muse
64

LAGOS
The Movable City
68

MUMBAI
The City as the Big Fish Eating
the Little Fish
72

BEIJING
The City Commodified
76

HONG KONG
An Old City in a Young Body
80

TOKYO
The City in a State of
Perpetual Conception
84

SYDNEY
Cities in the Mirror
88

RIO DE JANEIRO
The City's Plumage
92

BOSTON
A City Re-Personified
96

MANHATTAN
The City Dissected
100

CHICAGO
The City as Exemplar
104

NEW ORLEANS
The City Defying the Clock
108

DALLAS AND
FORT WORTH
Cities Born Accidentally
on Purpose
112

SAN FRANCISCO
The City Rejects the City
116

LOS ANGELES
The City as Phantom
120

DUBAI
A City of Visitors
124

INTRODUCTION

OUR CITIES ARE PERSONIFIED every day in the talk of their citizens, so why not in their imagery? Central Park might very well be the lungs of Manhattan, the Grote Markt the heart of Antwerp, and the London Underground a place in London's bowels. But where are the toes, the ribs, and the brains of our cities?

Such urban anthropomorphism and linguistic fancy is usually partial. It is rare to find all of the organs of the city joined together and pictured literally as a single body. If all the constituent parts of the corpus could be located, would it even be possible to visualize our cities as virtual persons, embodying the physical presence of a place and the personality of the citizens who have enabled their cities to grow, mature, and live in the world?

This book is a compendium of twenty-eight cities shown miraculously assuming human and animal form. Paris as Lady Liberty, Zurich as a gold-guzzling monster, Venice as the lion of St. Mark. Cities incarnate, cities whom we might meet in person. A naked, fleshy atlas.

With a stunning literalism, a plan of London describes passage through the city as if through the digestive tract of the human body. The tourist has to exit somewhere — Whitechapel in this case — and en route encounter the historic heart of Christopher Wren's cathedral, the seedy bars and gin joints of the liver in Soho, as well as plenty of spleen on Fleet Street, traditional home of the press and publishing. Each map in this atlas is defined by the particulars of geography, history, population, or, in the case of many places, good or bad reputation.

AS A CURIOUS AND ECCENTRIC EXERCISE, these maps appear to have been created very much in the spirit of the earliest mapmakers, who thought nothing of populating their beguiling cartography with any number of invented beasts, speculative infillings, and completely inaccurate and fantastic caprices.

This form of metropolitan iconography is part of a venerable and esoteric tradition. Architects in Renaissance Italy regularly based their designs on the human form, as an ideal of the perfect symmetry of the universe. Leonardo da Vinci's Virtruvian man applied the geometry of the ancient Roman architect Vitruvius to ideal human proportions to suggest that the way we are built should be the way our buildings and our cities are built. The Italian town of Sabbioneta is an example of how to build a city as a single piece of architecture, symmetrical like the human body.

In the nineteenth century, the art of the caricature map bitterly lampooned national political ambition or national victimhood by showing each as an appropriate animal, drawn to fit the outline of national borders. The octopus in particular was the creature of choice for embodying grasping nationalistic ambition, as in Fred W. Rose's 1887 map, which warns of Russia's growing influence. Robert Dighton's 1793 cartoon map depicts the figure of Britain created from the shape of the island, bombarding France from its rear with a "swarm of Bum-Boats." The strange, visionary, and genitalia-strewn maps of Opicinus de Canistris unequivocally revealed the latent anthropomorphic potential of terrain long before the machinations of modern national conflicts.

HOW DO THE MAPS IN THIS VOLUME sit within the realm of such precedents? And more to the point, where do they come from?

As a series, they look as if they have been collected, cataloged, or even created for a particular and unusual bibliotheca: an Institute of Corporeal Geography or a Library of Urban Anthropomorphism. Step into the partial limelight, Dr. London.

Partial, as little can be gleaned from the archives as to the person of Dr. London. Was the patron of this cartographic enterprise an age of enlightenment figure, a shadowy Dickensian sponsor, or a drudge of Grub St.? We will never know. It has not even been possible to date Dr. London, and, despite his geographically specific moniker, neither has a location for his library been fixed. What evidence there is has formed the kernel for this volume of drawings, which elaborates on a largely lost cartographic library.

Each map here is depicted within the pages of a different open book from the library of Dr. London, meticulously and imaginatively recreated from scanty scraps of information. The elaborate printed endpapers and fancy clasps of some volumes are drawn from the extant volumes that we know may have sat next to Dr. London's books. Depictions of other volumes show tatty, torn, and, in the case of Mumbai, grubby pages singed by the heat of the sun and nibbled by native paper beetles, which feed on paper made with rice starch.

The look and feel of each map, just like the contents of a returning traveler's suitcase, emit bewitching traces of other worlds, other histories, other peoples. Perhaps Dr. London, as an explorer in the vein of Marco Polo, having traveled to all these cities, is ultimately responsible for a project as grand as unifying all these places according to their common human qualities. We will never be sure, but in this book of maps, the realization of such a modern, speculative interpretation is given credible and aesthetically interesting form.

Many of the maps in this atlas certainly appear to have been created in situ, as a record of Dr. London's journey across a personable globe. In Istanbul, for example, a vision of the city appears to have been pieced together whilst navigating the Bosporus ferry routes, as if moving through the human nervous system. Other maps, such as that which depicts the corpus of Mecca, demanded a more oblique and sensible remove. The peripatetic map studio of Dr. London, from whence it is understood the maps sprang, was rolled up, boxed up, and folded up, ready for passage to another place of different character, in much the same fashion as Lewis and Clark's expedition, a caravan of camels, or the pitching map room of a transatlantic sailing vessel.

THAT WE HAVE TO RECREATE Dr. London's venture from such scraps tells us that Man's desire to impose his own image on the world's terrain is a project as confident and glorious as it is consistently thwarted. The same is true of the cities depicted by Dr. London. The taut sinews of the planned city grow loose and paunchy, whilst the friendly faces of other places are pummeled beyond recognition by all manner of tragic and unkind vagaries — historical, religious, or geographical.

These cities incarnate, though fixed in an atlas, laid out in illustrations, and viewed within crumbly old books, nonetheless achieve a certain life, hope, and vitality by being caricatured as the very citizenry who do not merely find a place to live but create life from that place.

JERUSALEM
THE CITY PERPETUALLY CONQUERED

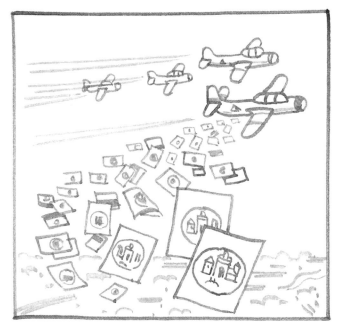

The real struggle of the conqueror is not to capture the citadel, but to capture the famously prized "hearts and minds" of its occupants.

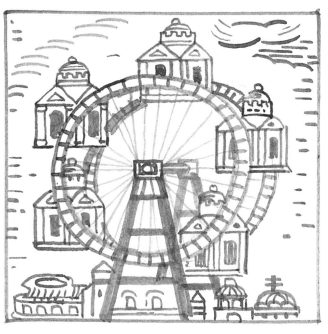

During such operations, it is rarely possible for one to determine the particular allegiances of said hearts and minds. Personified, the city might at any given moment in history have several allegiances.

That a number of conflicting "minds" can coexist and the corpus of the city continue to function normally is a testament to an equality in the appeal of different ideologies.

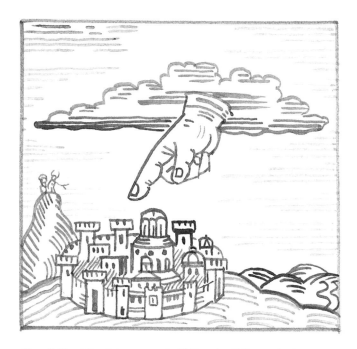

The difficulties "the occupied" face in differentiating between several identical heads may account for their ceding responsibility altogether, choosing to identify as having been chosen rather than choosing to choose.

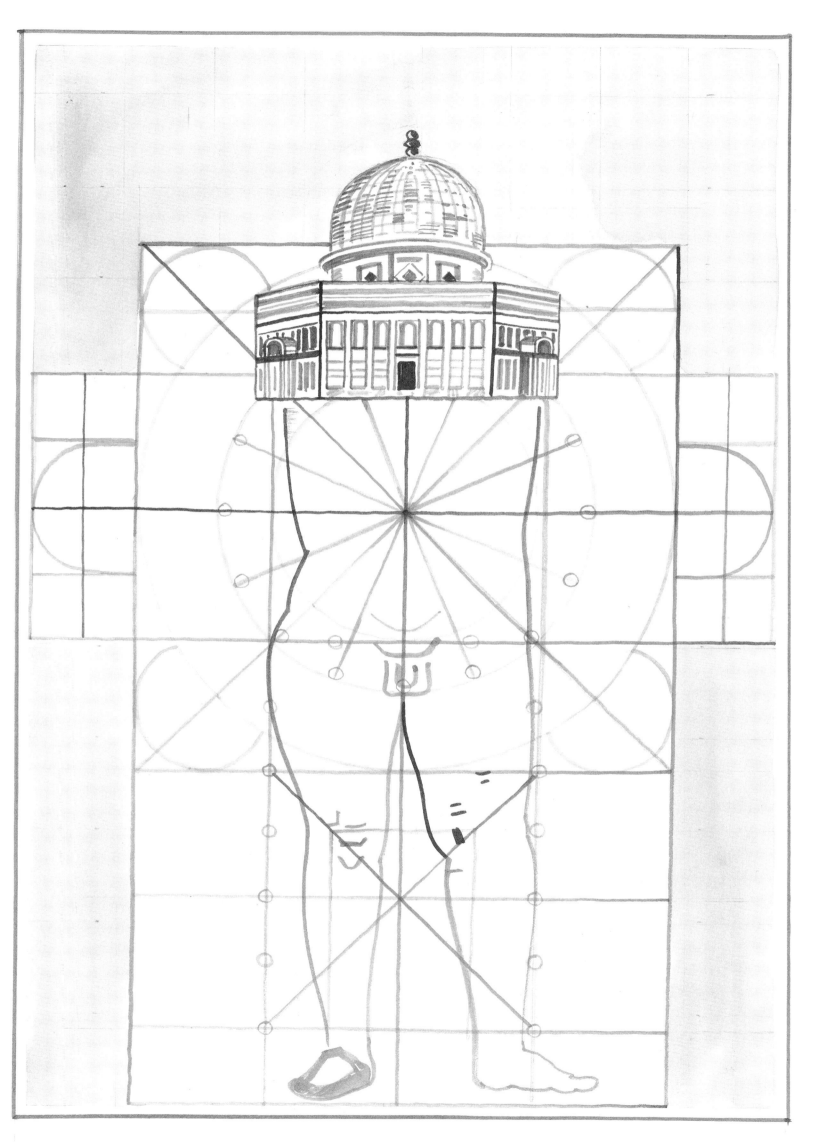

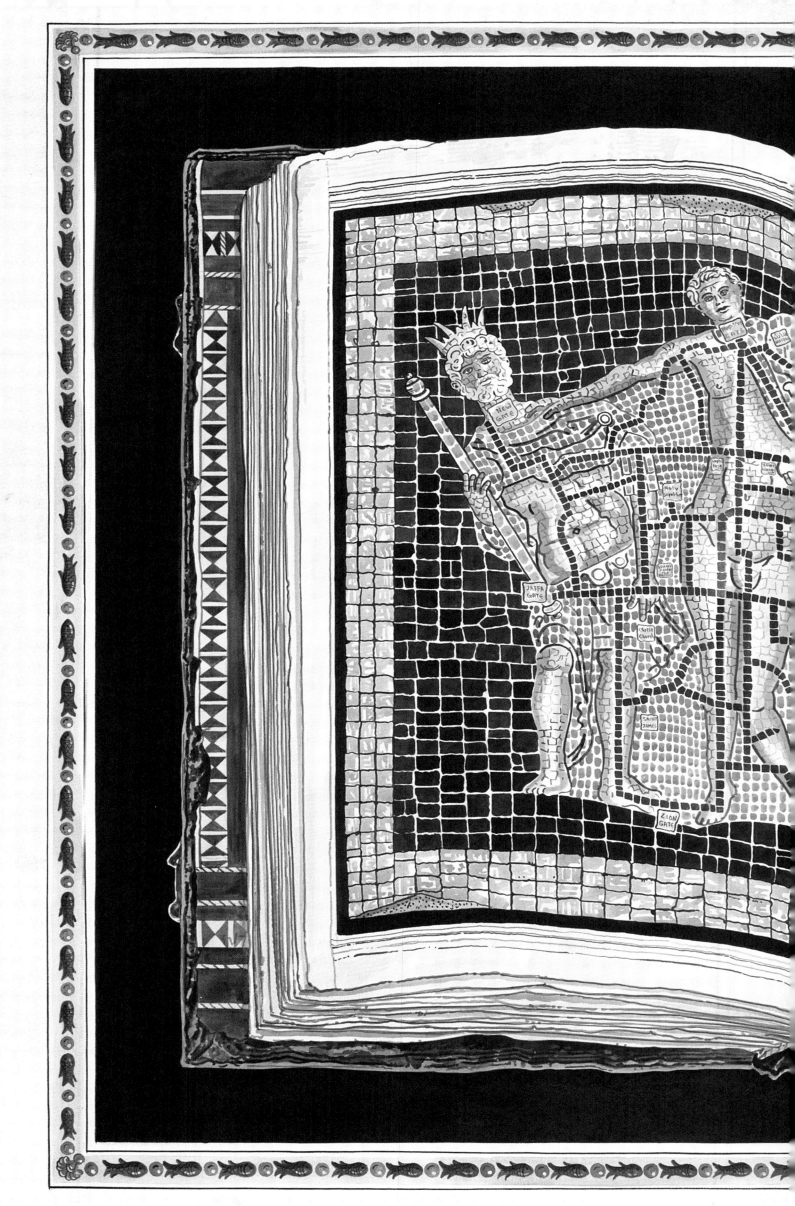

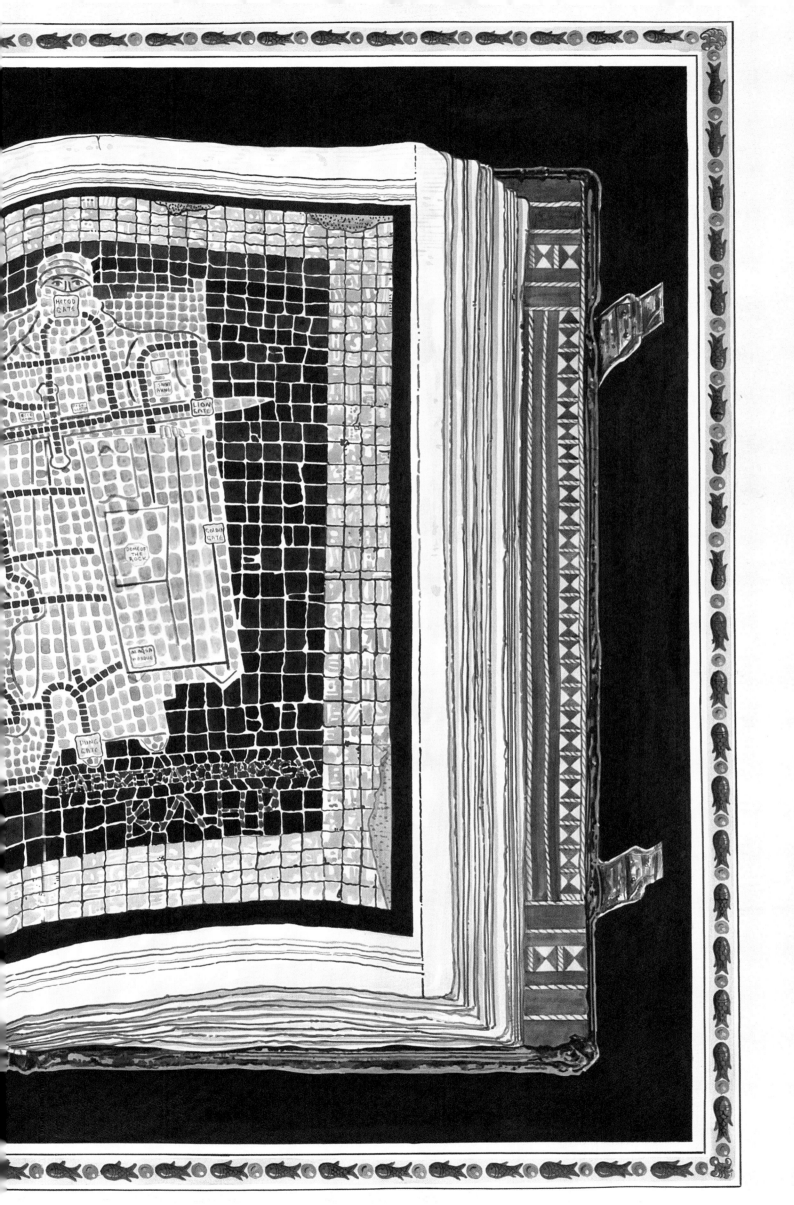

MECCA

THE CITY AS THE CENTER OF ATTENTION

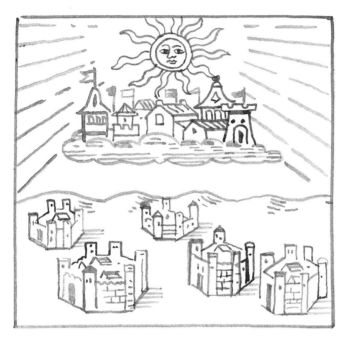

The city personified as being above and beyond all others might be expected to have a presence that dominates and controls every aspect of not just its own citizens' lives, but also the lives of others.

With the status of "city supreme" comes the burden of being perpetually the center of everyone's attention, wherever everyone happens to be in the world.

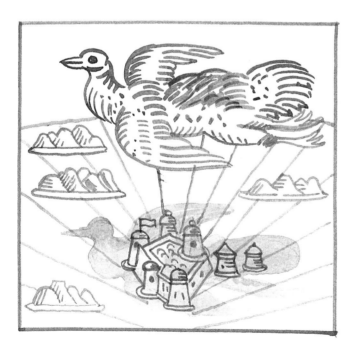

However, the omnipresence of such a city, and its demand for total and regular regard, might in fact serve the opposite purpose.

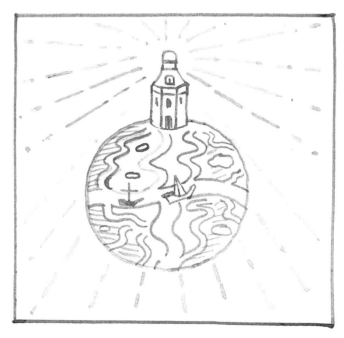

A city that asks to be continually observed could in fact be hiding its true intent in plain sight: not to be always seen, but to be all-seeing.

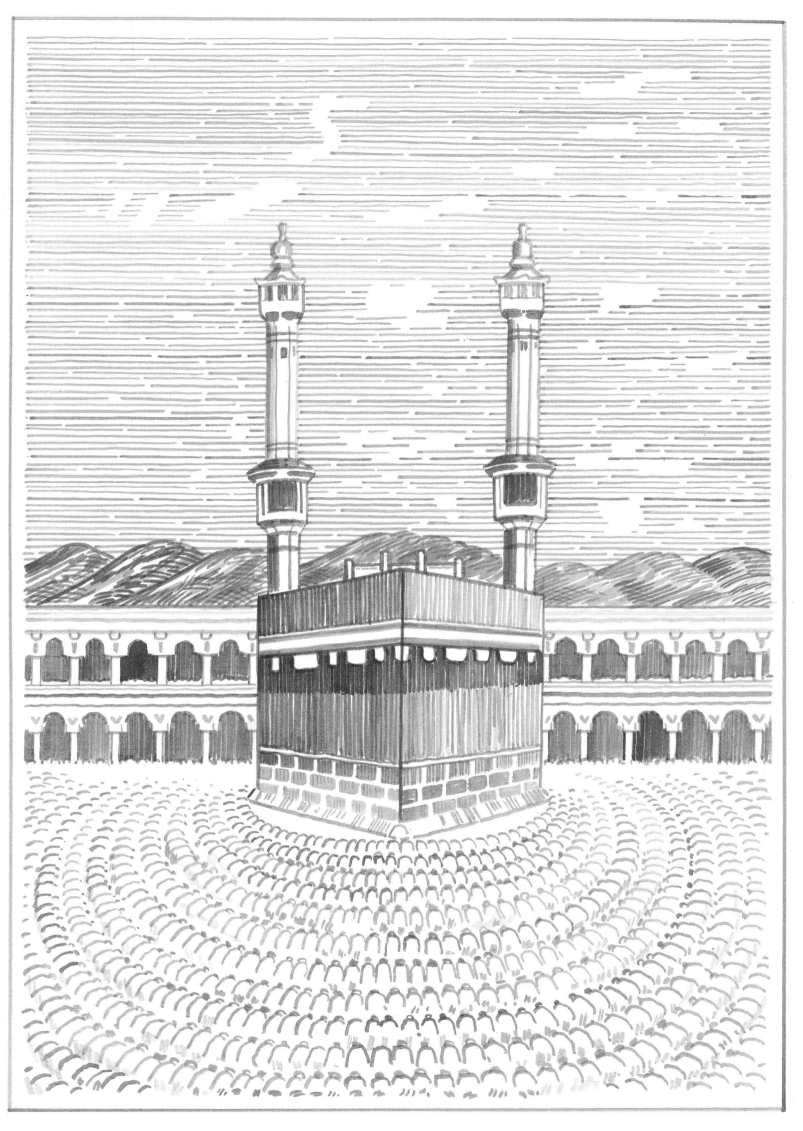

ROME

THE EXTRA-LIMBED CITY

The city as an embodiment of God's greatest creation bears the same perfect symmetry as man. Bisected by a central spine, which leads from a cerebral point of entry to a crucial crux, everything falls into place as nature intended.

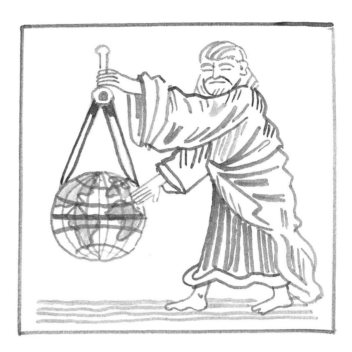

However, the perfect order of such a place, because of its primacy among its kind, is spoiled in monstrous fashion by the intervention of its own creator.

The appearance of the puppet master's arms, however convincing the puppet, always severs the strings of belief. The marionette is made inanimate or, if it remains alive, is rendered grotesque by additional limbs.

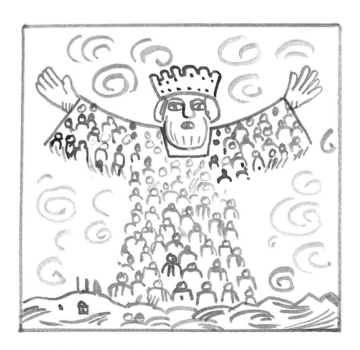

Here in the extra-limbed city, the creator and the creation, puppet master and puppet, coexist, exposing the fallacy that the city governs itself or that it has come into existence without agency.

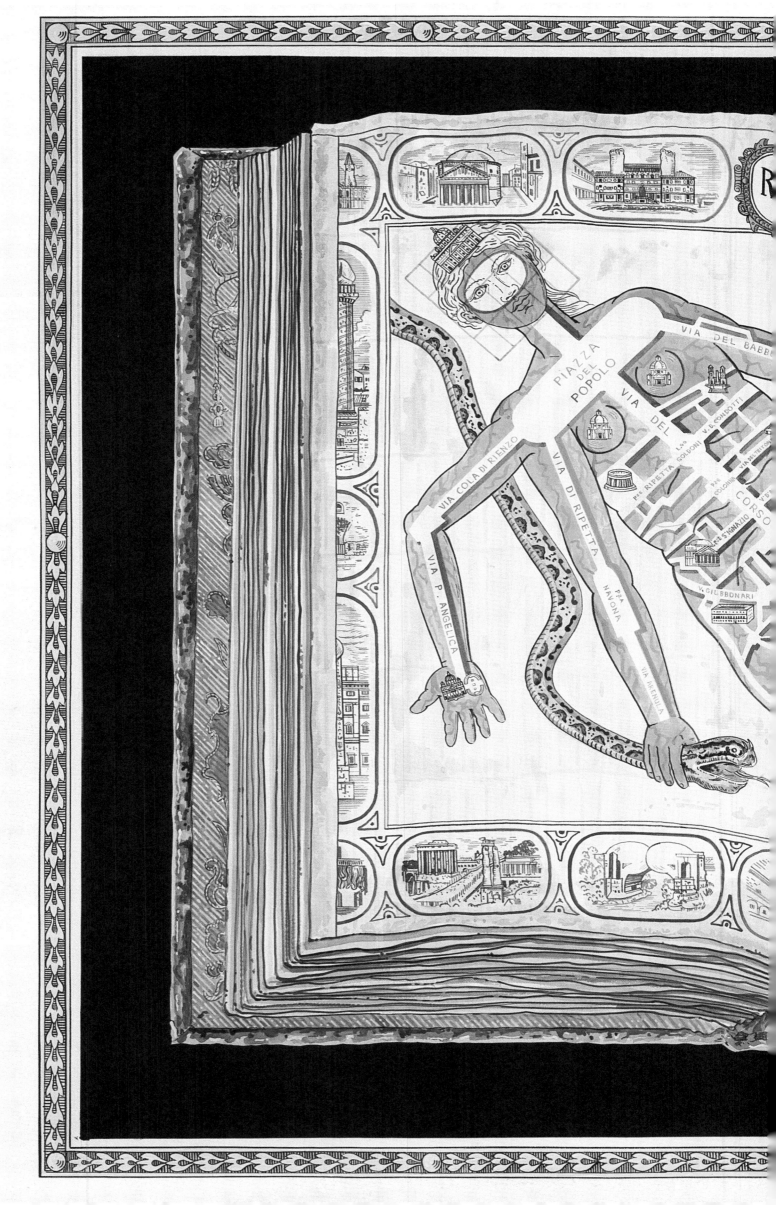

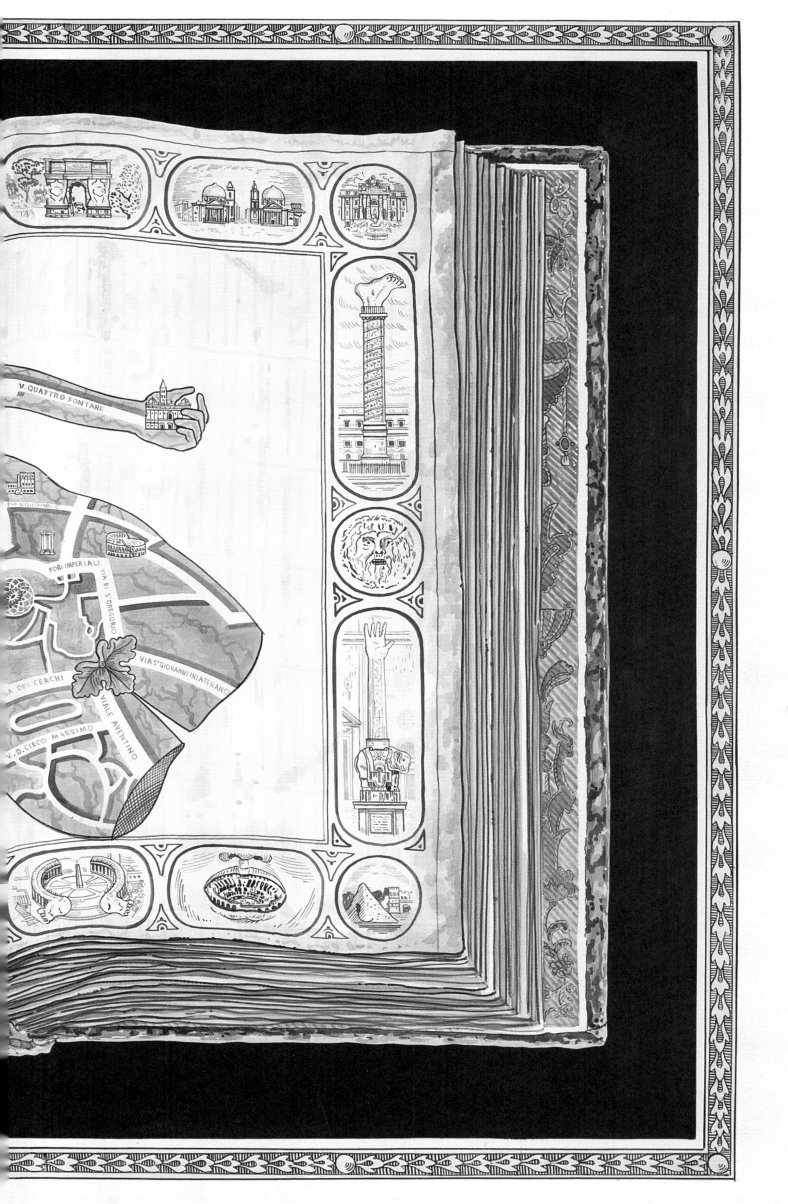

VENICE

THE CITY AS THE MOUTH OF THE COUNTRY

In reality, as opposed to the fake visions found in guidebooks, the anthropomorphic quality of a city is best appreciated from afar. To enter a city is to be consumed by it. Its presence as a single entity is soon forgotten as the visitor becomes entangled in its tripes.

It could be said that the city must consume its own citizens and its visitors in order to survive. Without the nutritional constituents required for life, growth, and transformation, the city atrophies like a caged, starving beast.

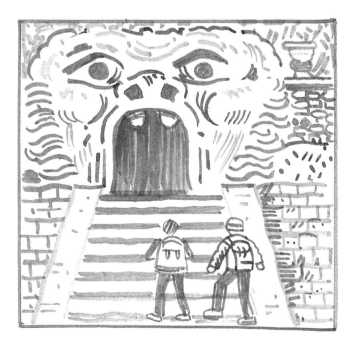

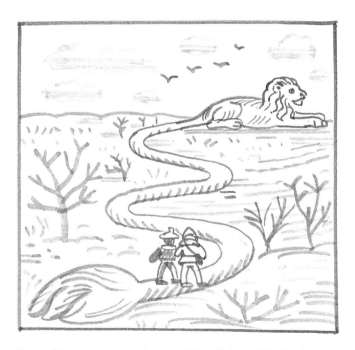

Do the perennial attractions of the city exist merely as bait to lure the unsuspecting traveler into its open maw?

It would appear so, as the twinkling lights of the harbor draw in vessels from far and wide, and what appeared from a distance to be the gleaming marble cupolas of churches and palaces turn out to be rows of sharp, white teeth.

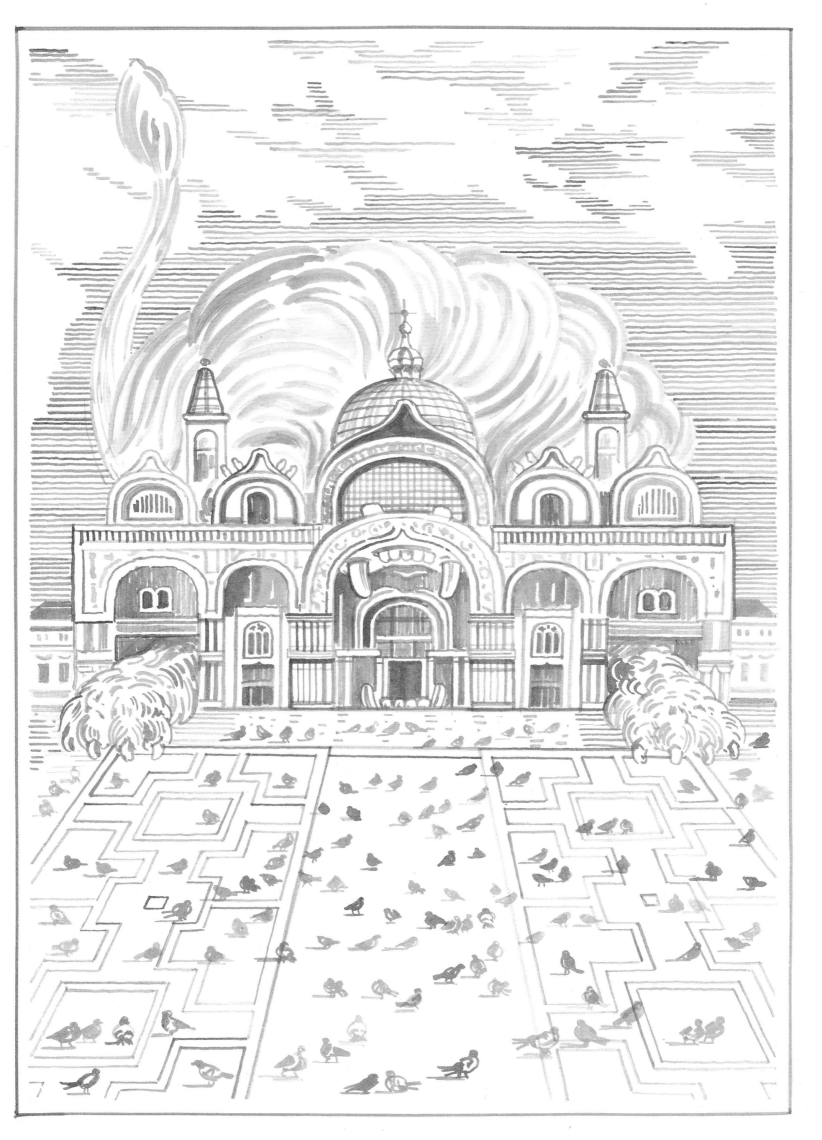

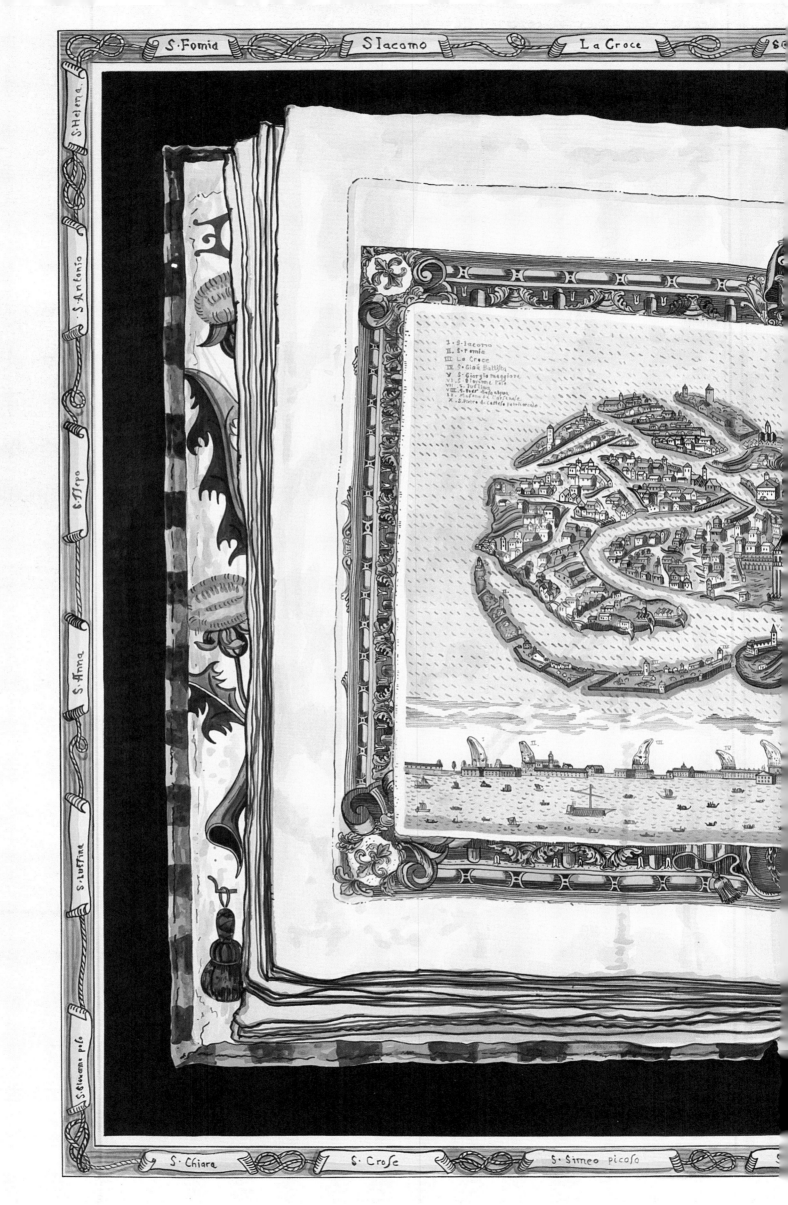

I. S·Iacomo
II. S·Fomia
III. La Croce
IV. S·Gioa Battista
V. S·Giorgio maggiore
VI. S·Iustina
VII. S·Pier d·la chiesa
VIII. S·Pier d·la chiesa
IX. Madona de l'arfenale
X. S·Pietro di castelo patriarcado

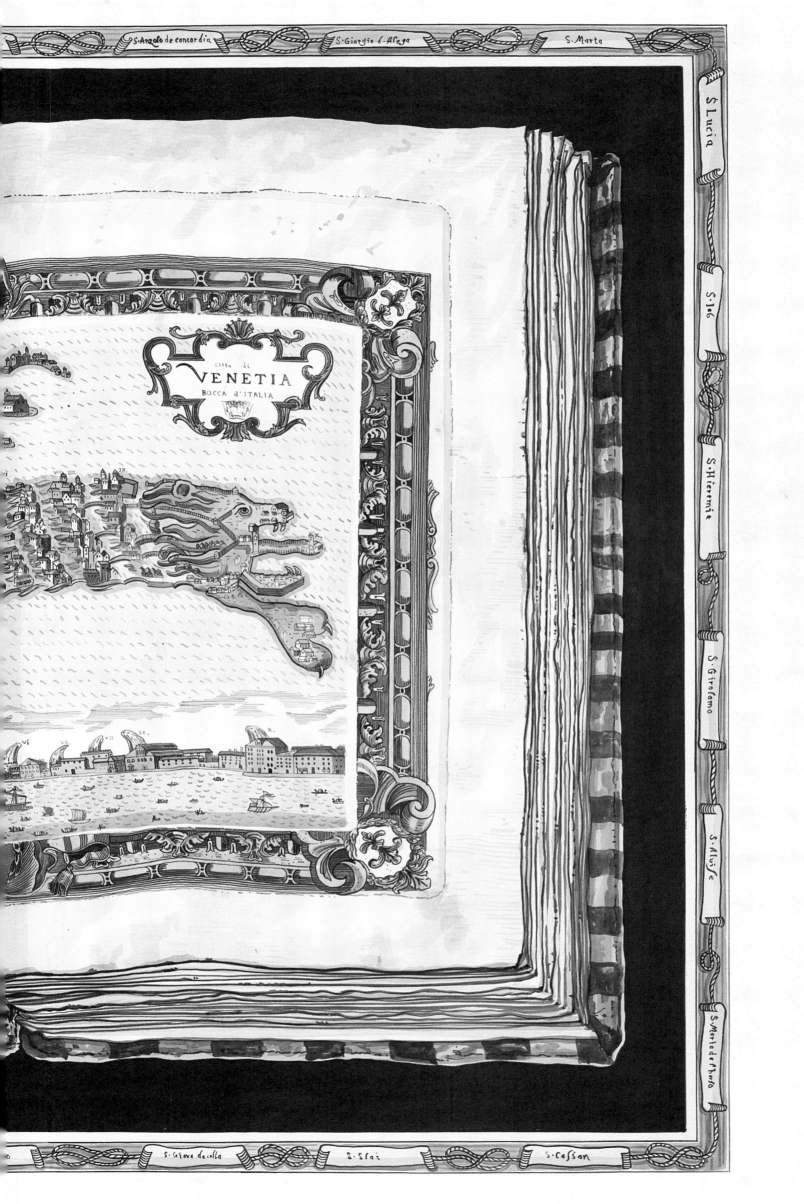

citta di
VENETIA
BOCCA d'ITALIA

S. Lucia

S. Iob

S. Hieremie

S. Girolamo

S. Aluise

S. Marta d. Servo

ISTANBUL

THE NERVES OF THE CITY

In the hierarchy of a city's constituent parts, there are many passes and passageways that serve only as realms of conveyance. These are not good stopping off points, and with good reason. Stopping in these parts leads to blockage, clotting, and general traffic problems.

Despite lacking the status of "destination," such routes are still described as "places" and, more often than not, are the primary and most useful focus when we map out the city.

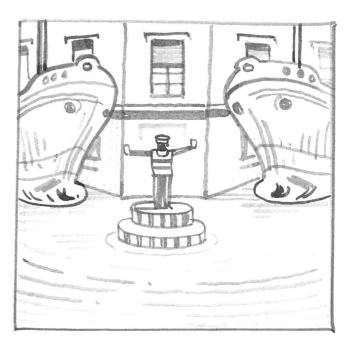

Given form by the lifeblood of the city, they define a place via its negative space, by being between where we are and where we are going.

Testing "the nerves of a city" thus involves traveling its entirety, from thought to action, cause to effect. There is little point in getting under the skin of a place merely to be a splinter when we could instead be feeling its throb.

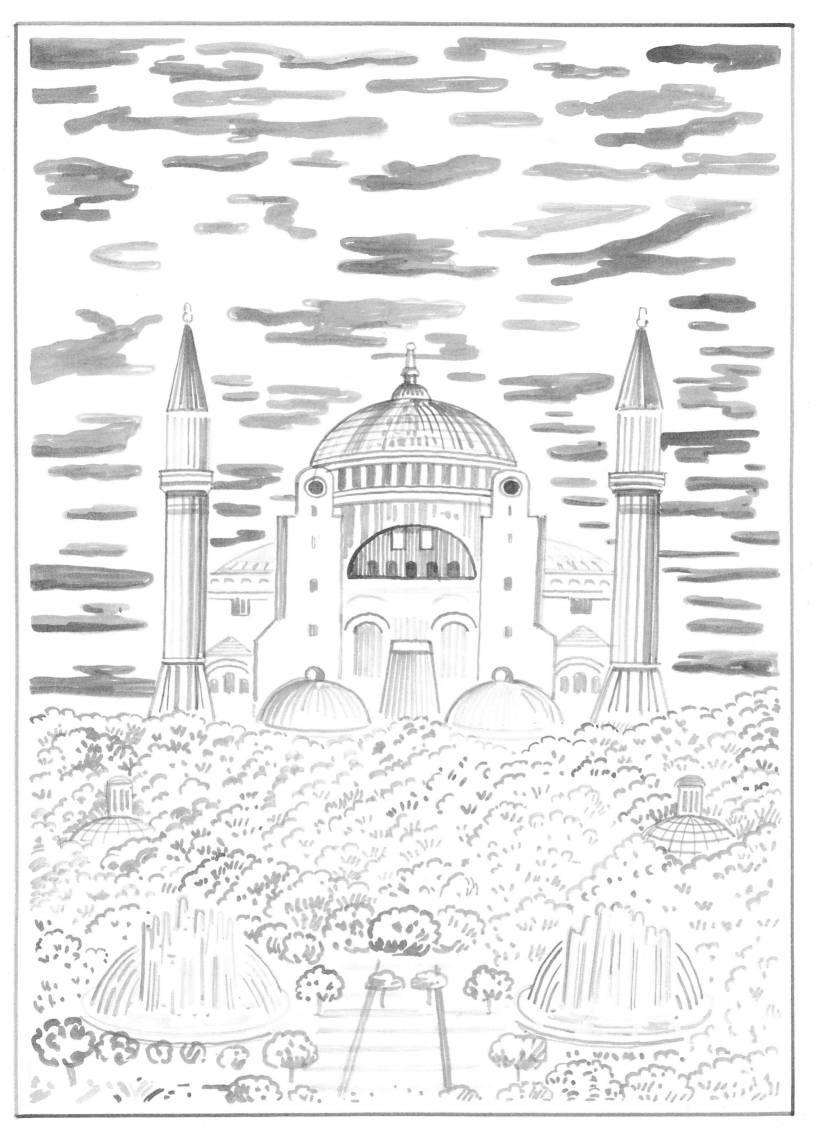

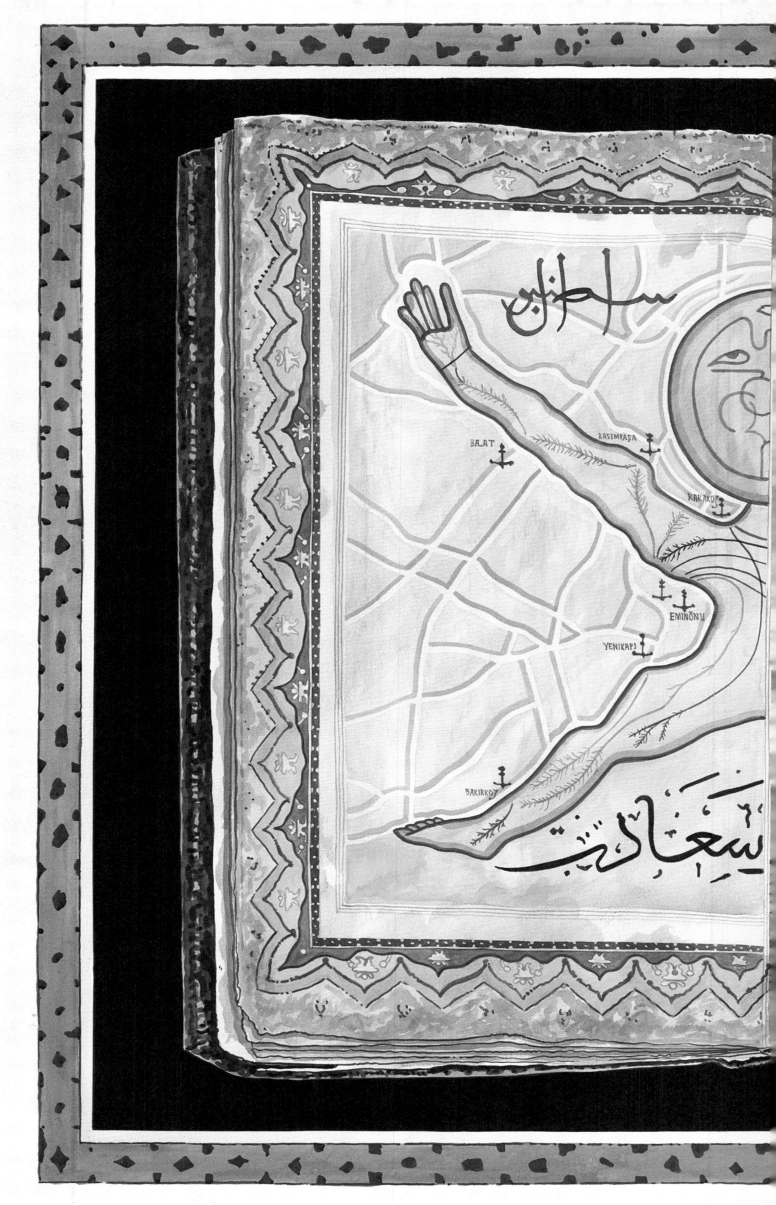

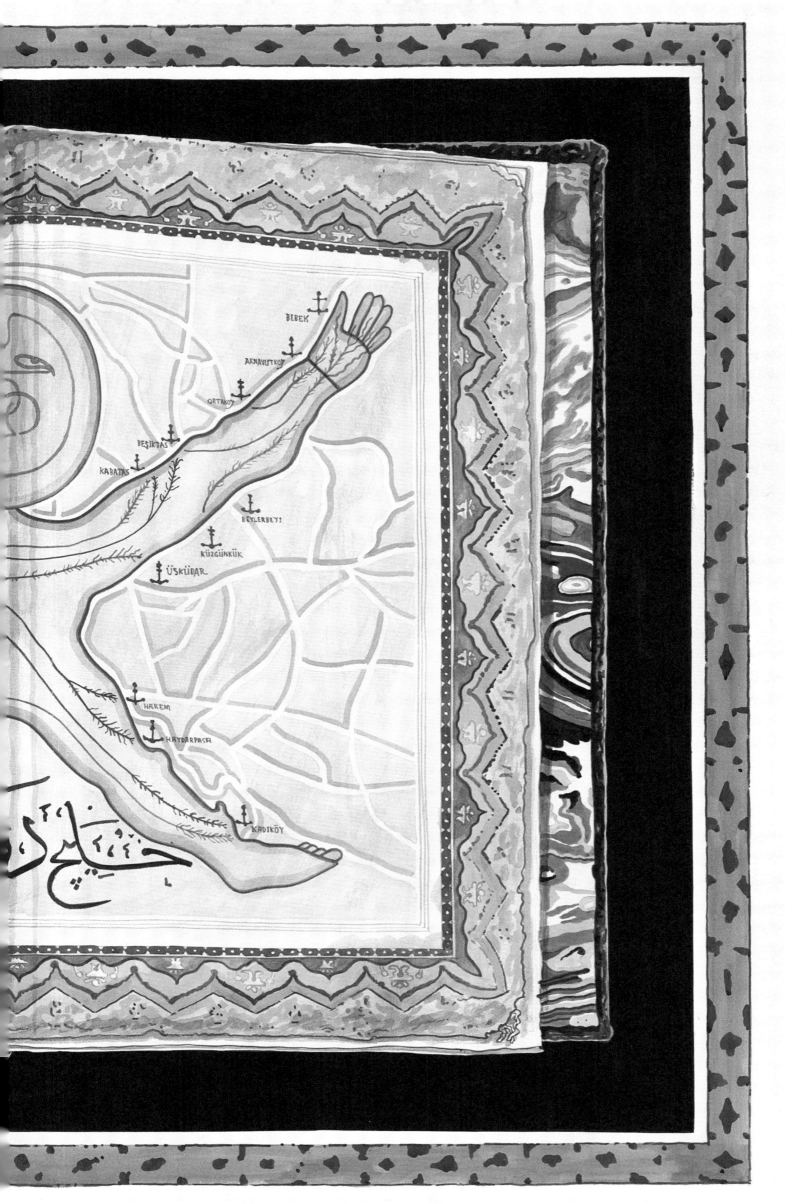

PARIS
THE BONES OF LIBERTY

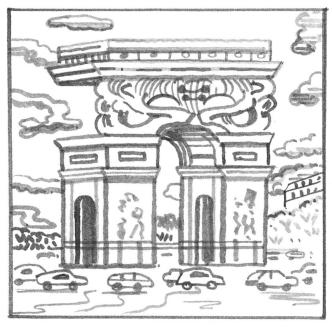

To speak of "the bones of a city" most obviously implies that, like the human body, the city has a skeleton onto which pulsing, fleshy, sensual parts cling or are grafted.

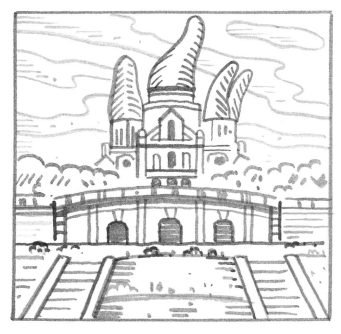

The urban skeleton, like the human skeleton, grows; suffers fractures, aches, and infections; has an unpleasant appearance when denuded; and eventually returns to the dust from whence it sprang.

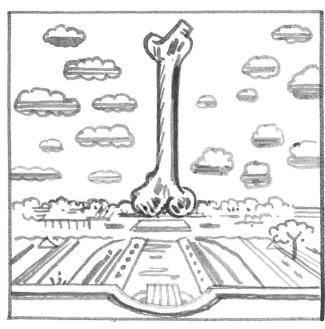

In another sense "the bones of a city" might refer to a collection of sacred relics: objects of veneration that symbolize the systems of belief on which the city is founded.

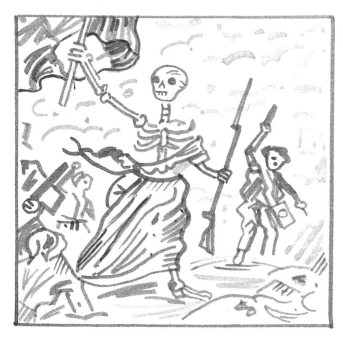

The edifices that we build in such cities become tangible manifestations of these resurrected bodies and the sainted principles which we worship and adore.

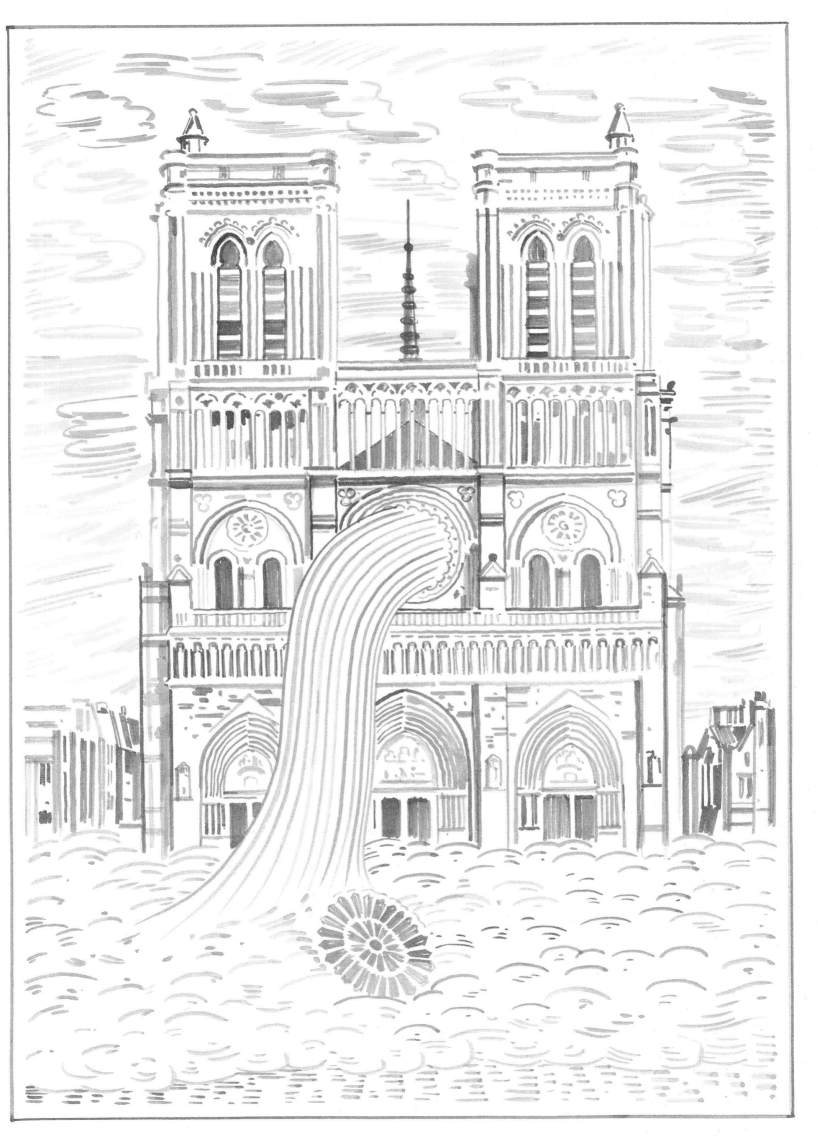

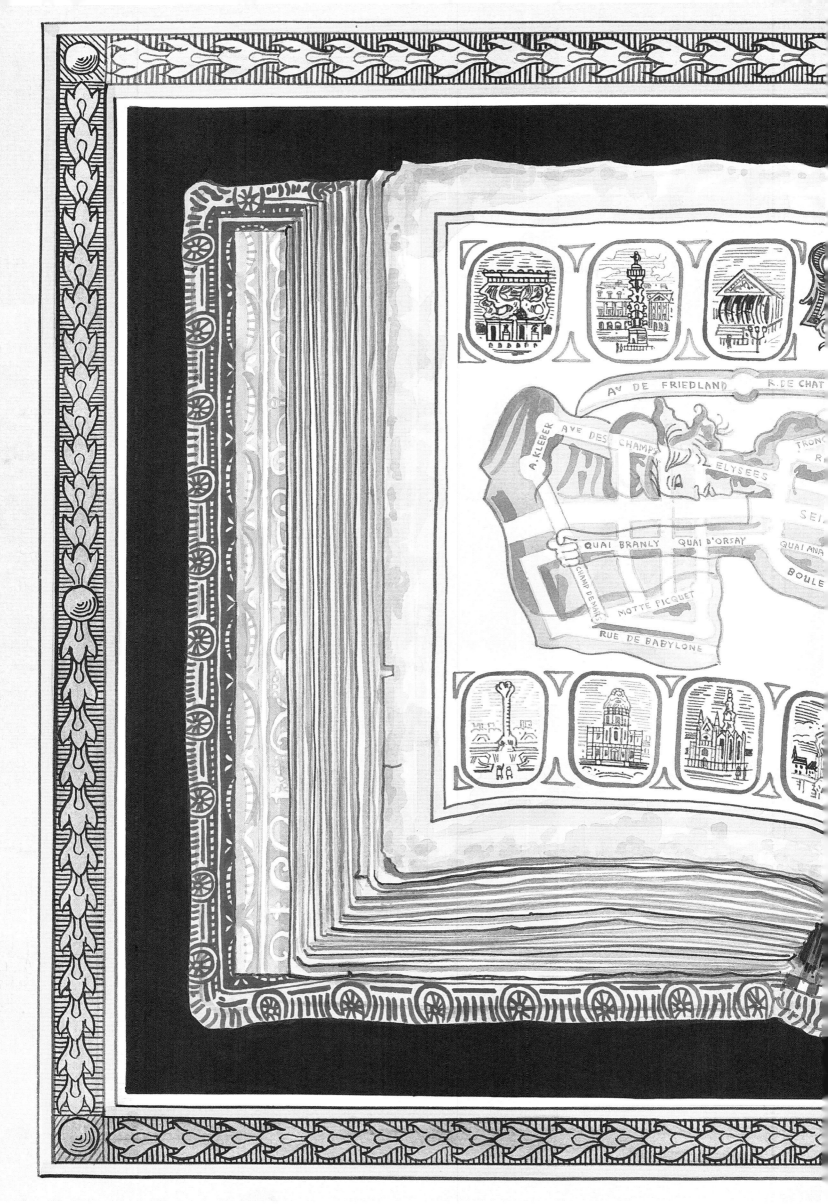

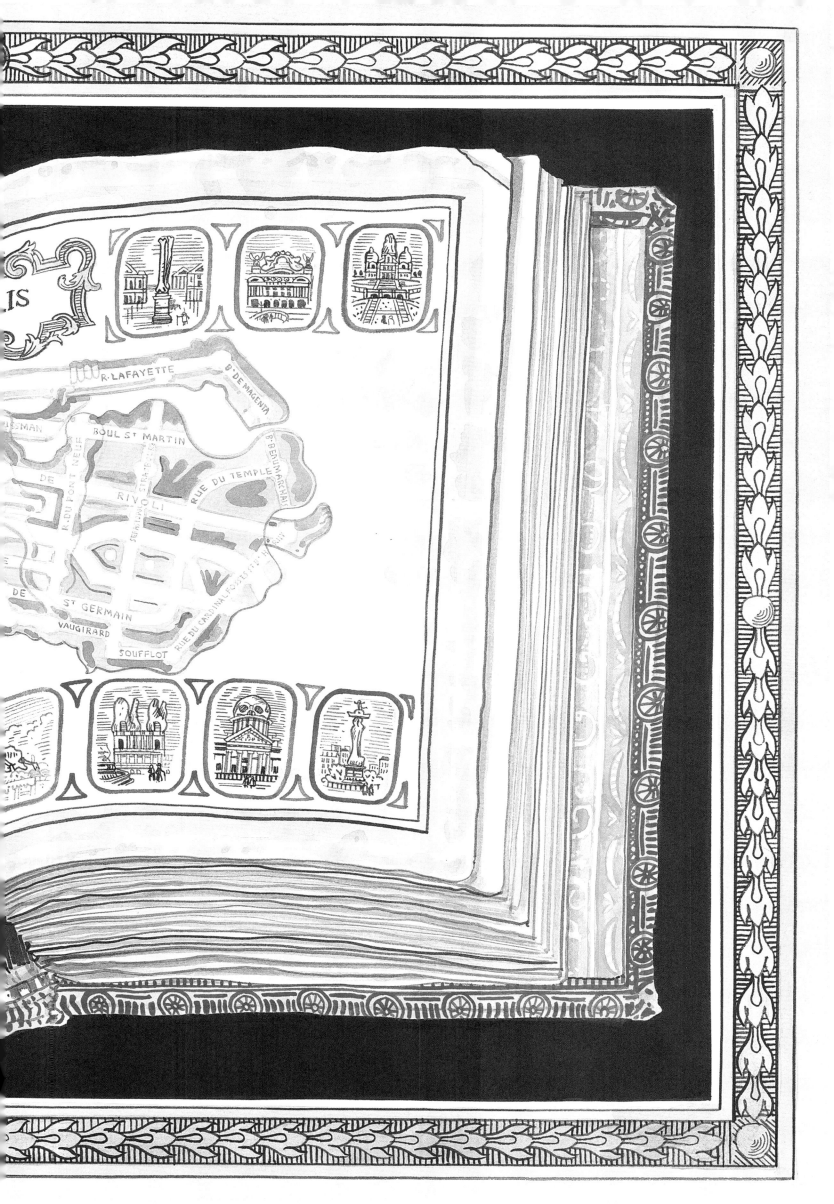

ZURICH

THE MOUTH OF HELL

In a city where the love of money appears to be the prime concern of its residents, the streets all lead to one place.

The activity of amassing an enormous trove in the bowels of the city is as all-consuming as it is ceaseless.

Due to the less than nourishing quality of gold, the body of this city typically begins to feed off itself.

Fortunately, the emaciation that follows such self-cannibalization is often well hidden under a dense, opaque, and rather frosty cloak.

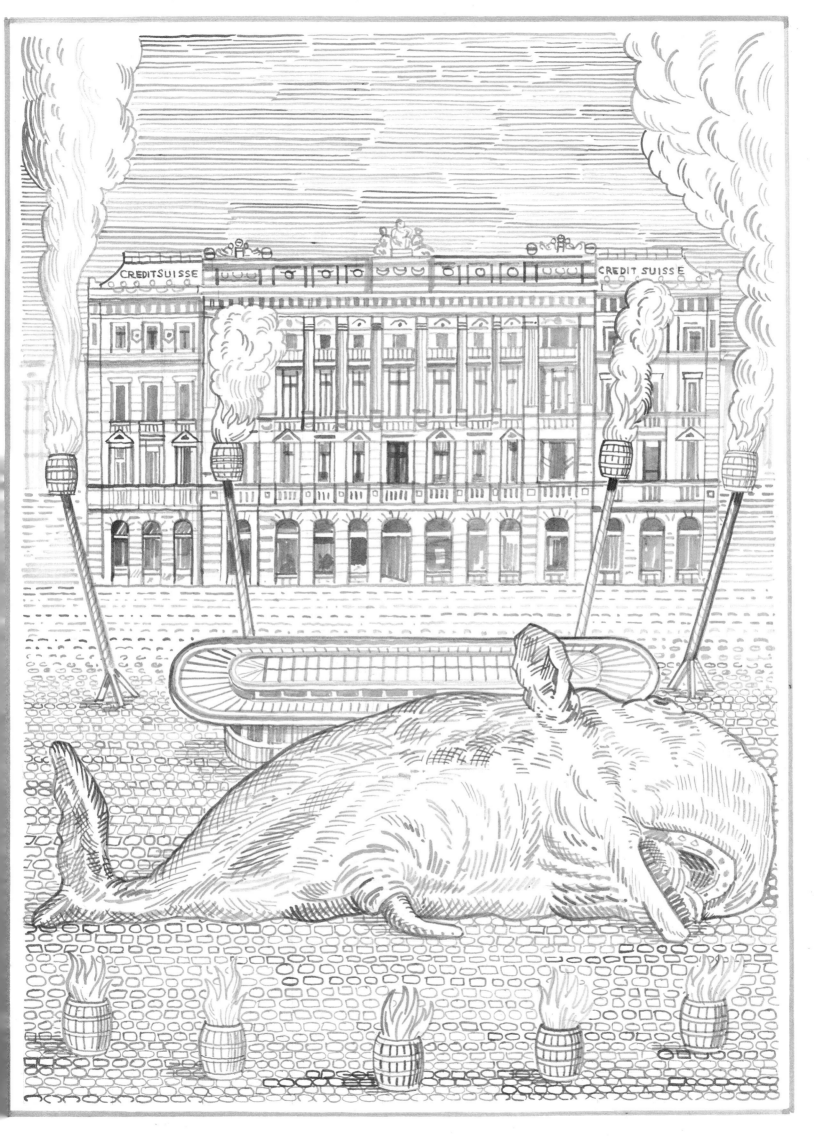

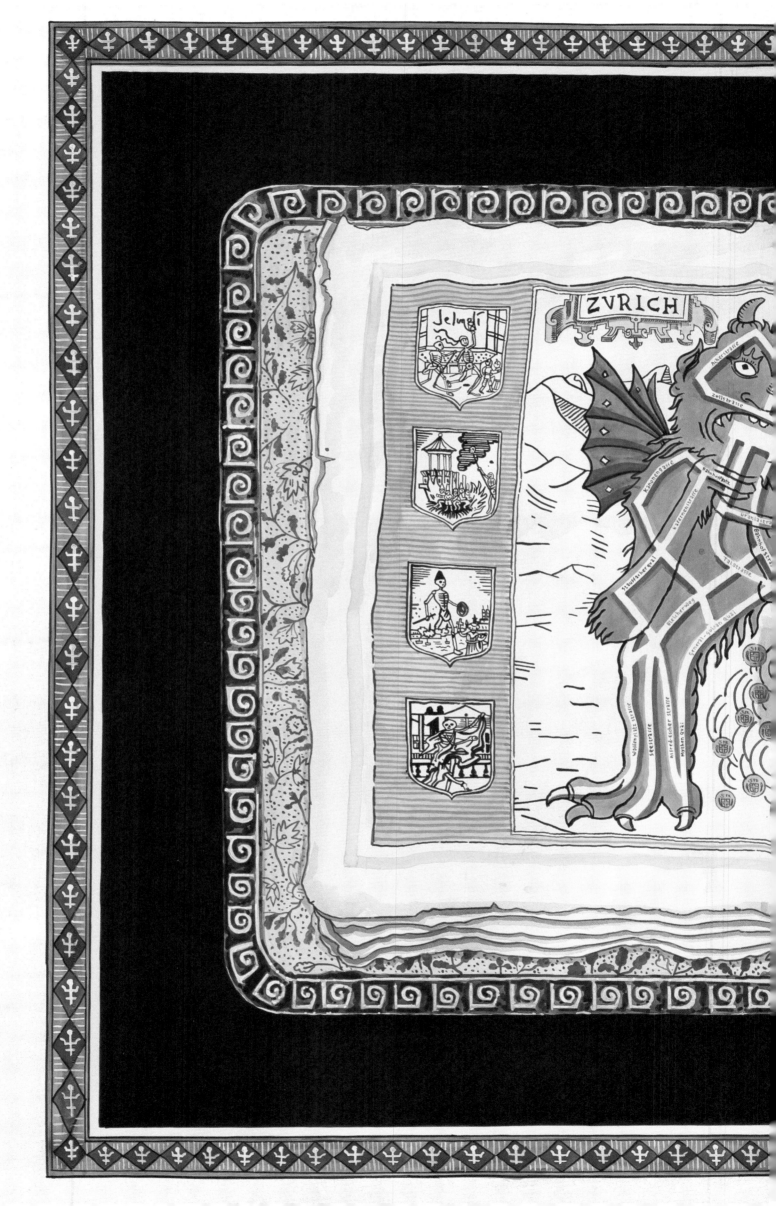

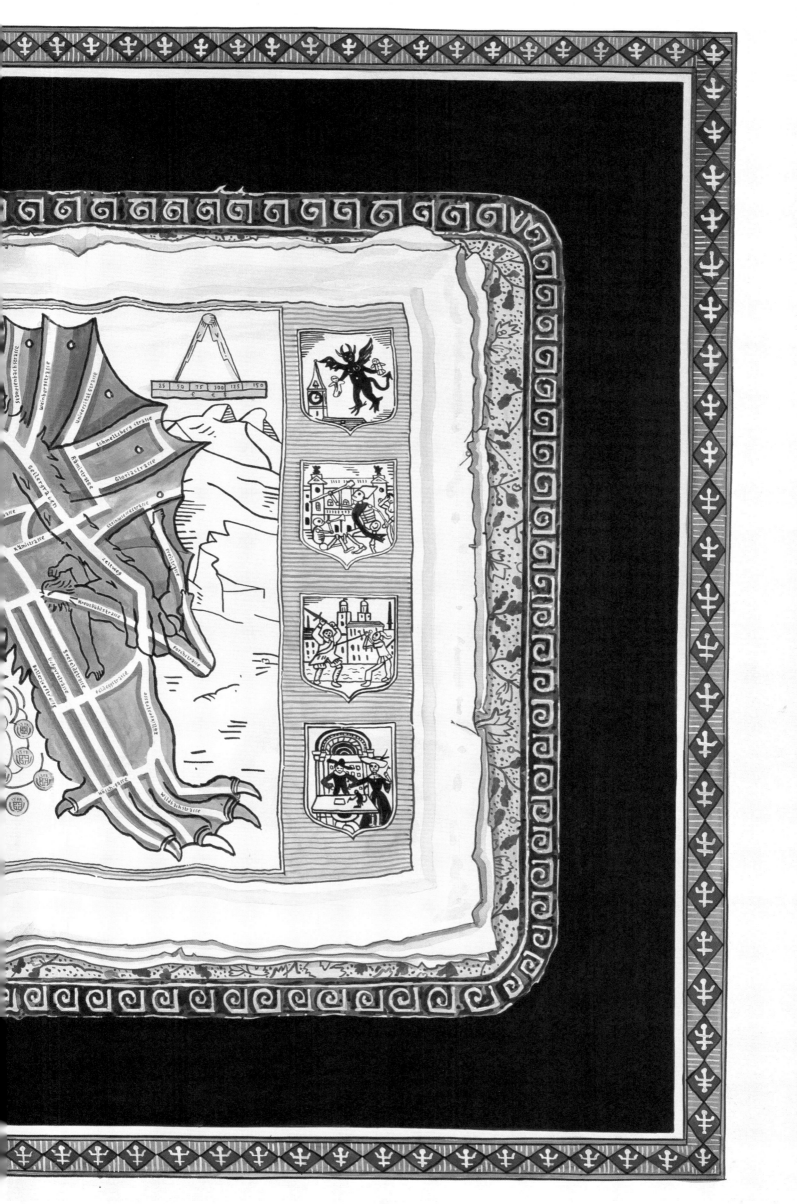

MOSCOW

THE CITY OUT OF REACH

Like the haughty object of one's affection, a city might be construed as unobtainable for several reasons.

Whilst the magnetism of a place might be captivating, it may still resist capture. Traits such as a city's location, the resistance of its inhabitants, and its sheer unwillingness to yield all contribute to its position as "beyond taming."

The seeming ease with which such cities might be taken, in the minds of those driven wild by a desire to do so, always ends in disaster and ignominious defeat.

That such unobtainable cities appear to revel in their rejection of suitors begs the question as to whether their perpetual allure exists solely for such a purpose.

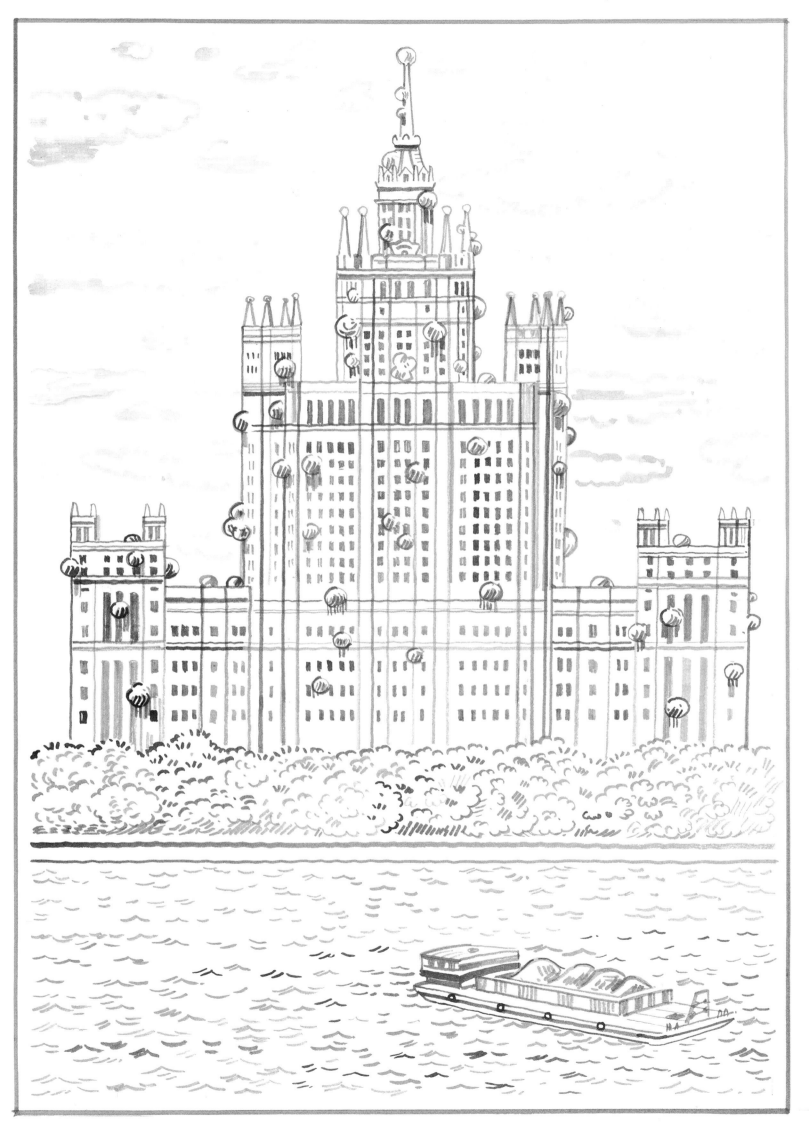

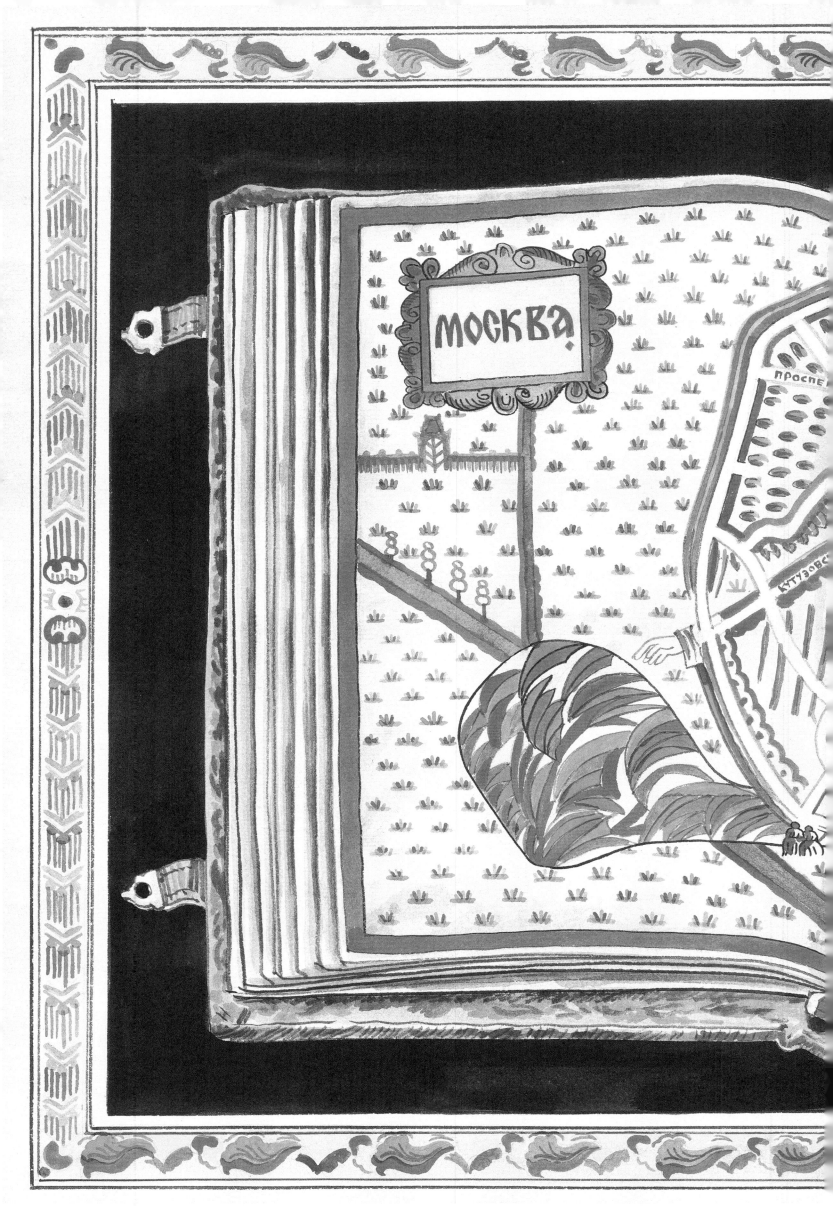

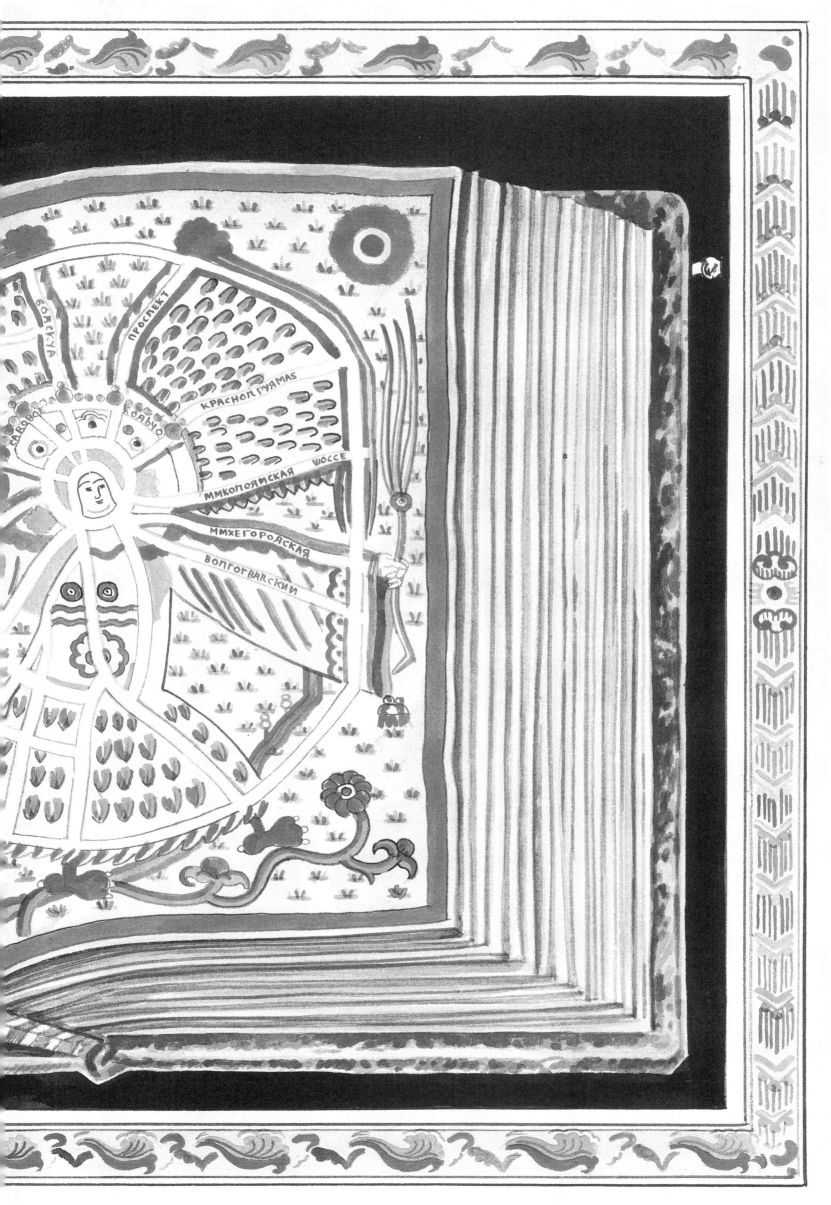

COPENHAGEN

FAIRY-TALE CITIES

A fairy-tale city, or a city embodied as a character from a children's story, is condemned to repeat its fate ad infinitum.

Whether this fate consists of endlessly spinning straw into gold, or gazing mutely out to sea awaiting a deliverance that will never come, the denouement for such cities can be reassuring in its inevitability.

The anticipated happily ever after that these cities offer their citizens is a comfort blanket of uninterrupted sweet dreams.

That personifying a city according to didactic myth might also lead to nightmares is perhaps not as interesting, or as telling, as the information that is dredged up in the interpretation of these troubled reveries.

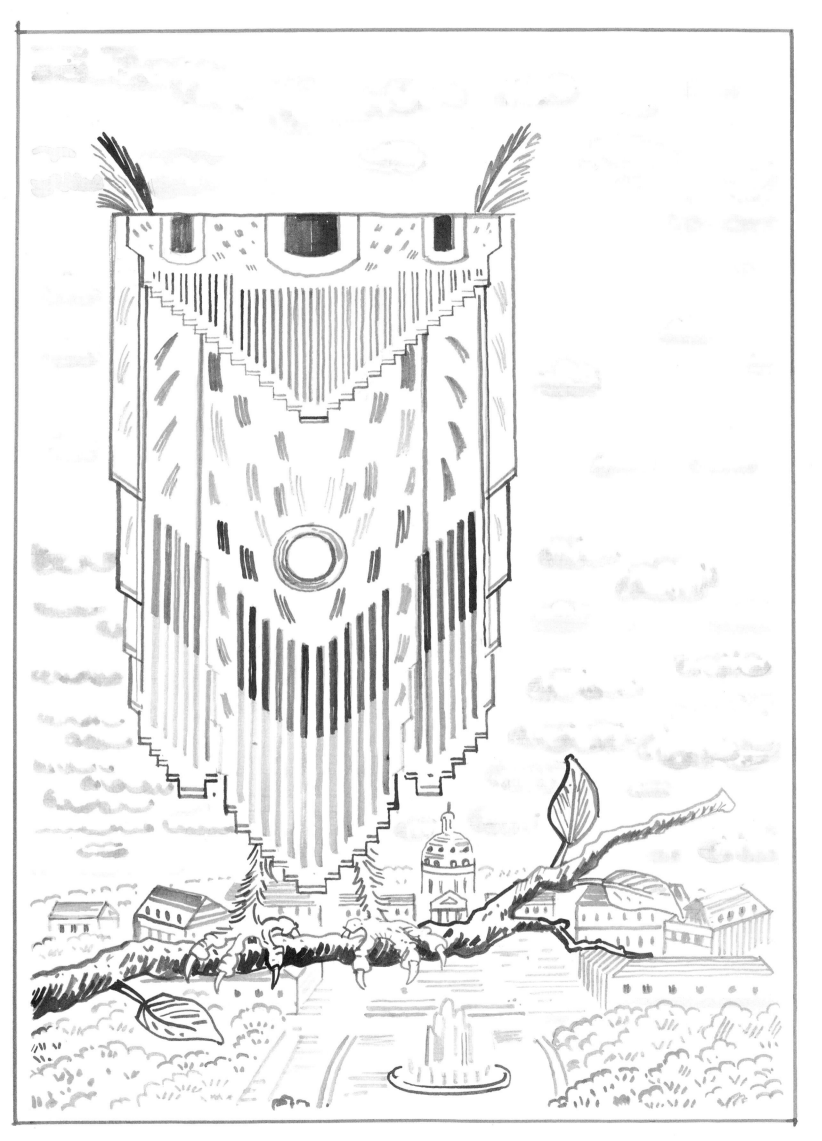

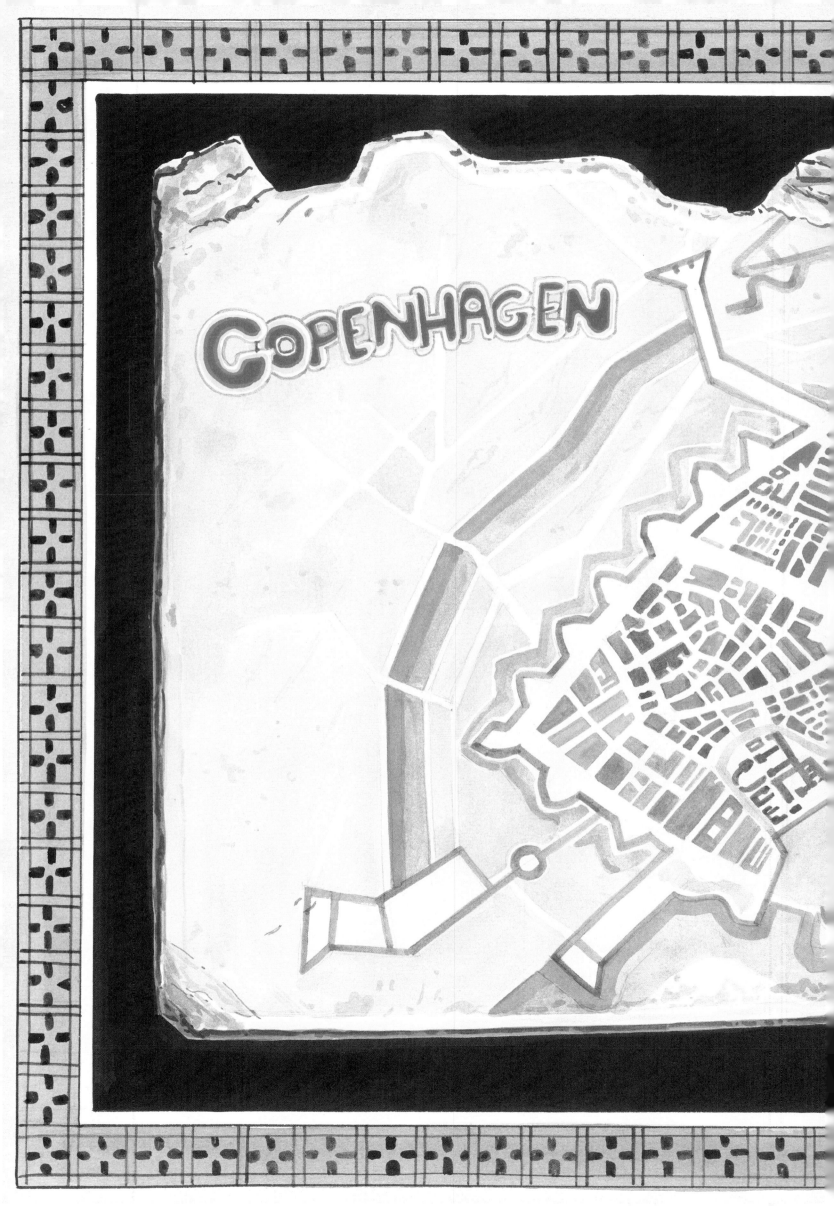

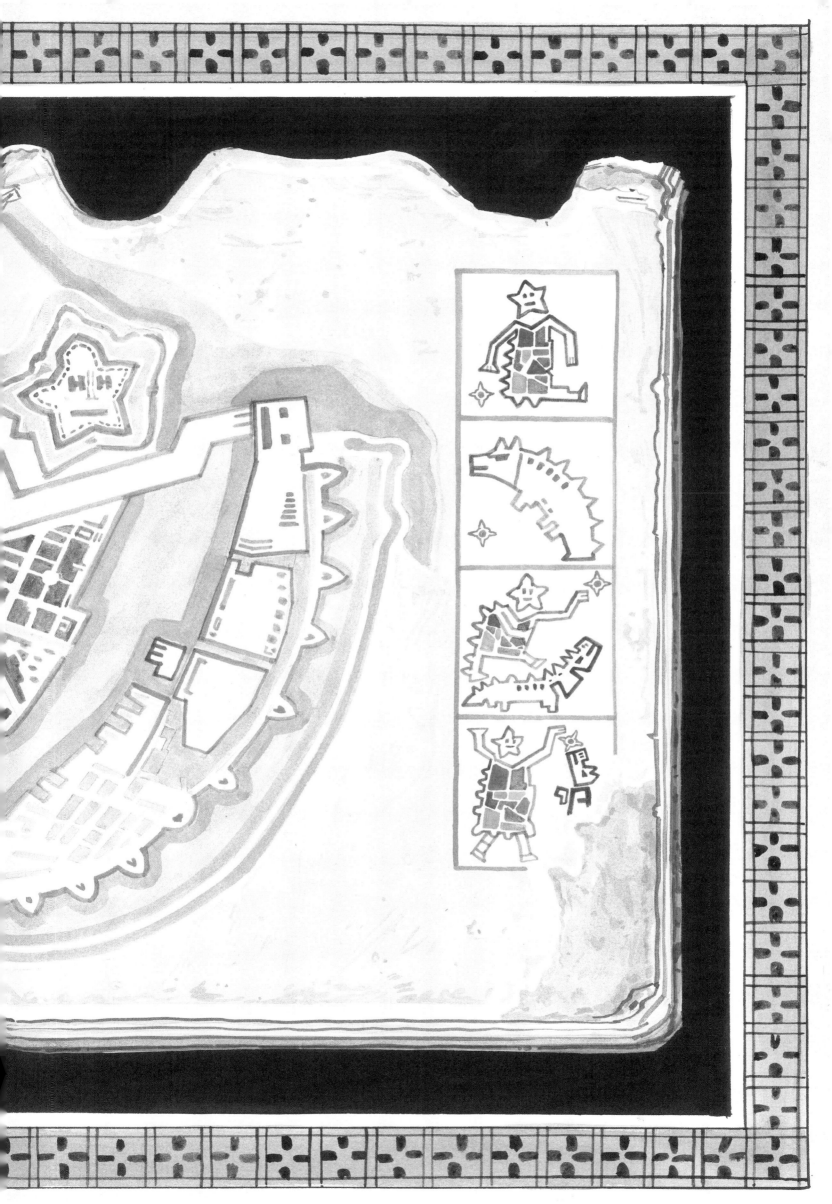

AMSTERDAM

THE EVER-EXPANDING CITY

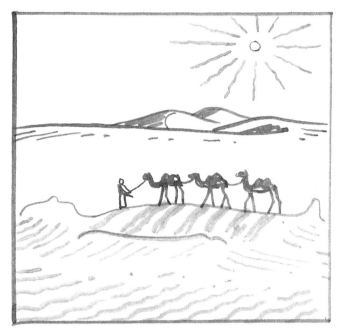

In a postcolonial age, a city's imperialist aspirations turn back on themselves and become a battle for the conquest of the self

In a city whose coffers once swelled with bounties from secure trade routes, the distribution and acquisition of goods from afar continues apace, with even more speed and even less effort.

Now that such former empires' extramural larders no longer exist, cities still in receipt of a surfeit of goods but with nowhere to put them must exercise restraint. Ingesting more than it needs will soon result in a city becoming overstocked and stretched to bursting.

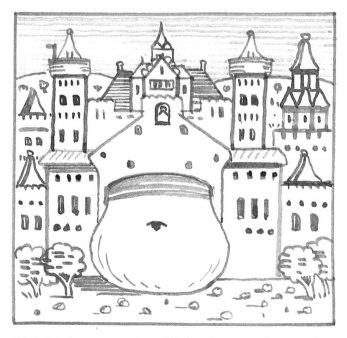

Maintaining a correct equilibrium between the appetites of a city and the external forces that continue to act upon it is essential if a city does not want to get fat.

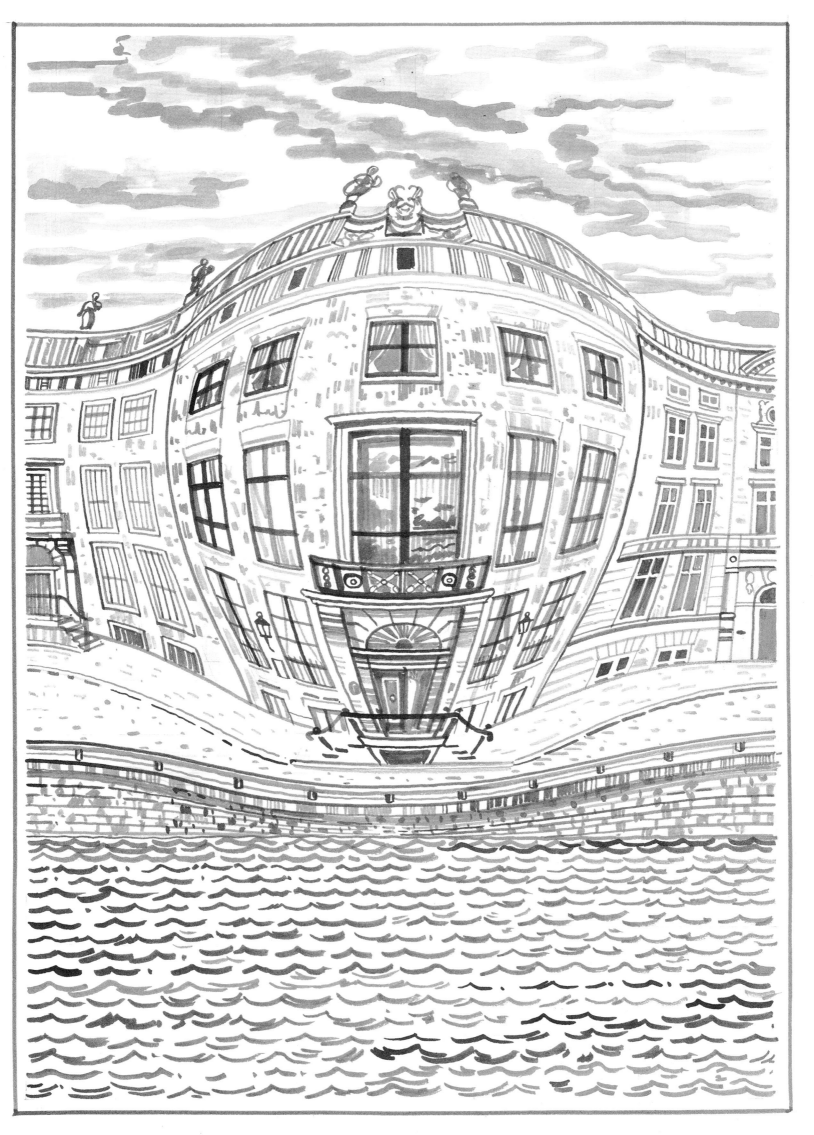

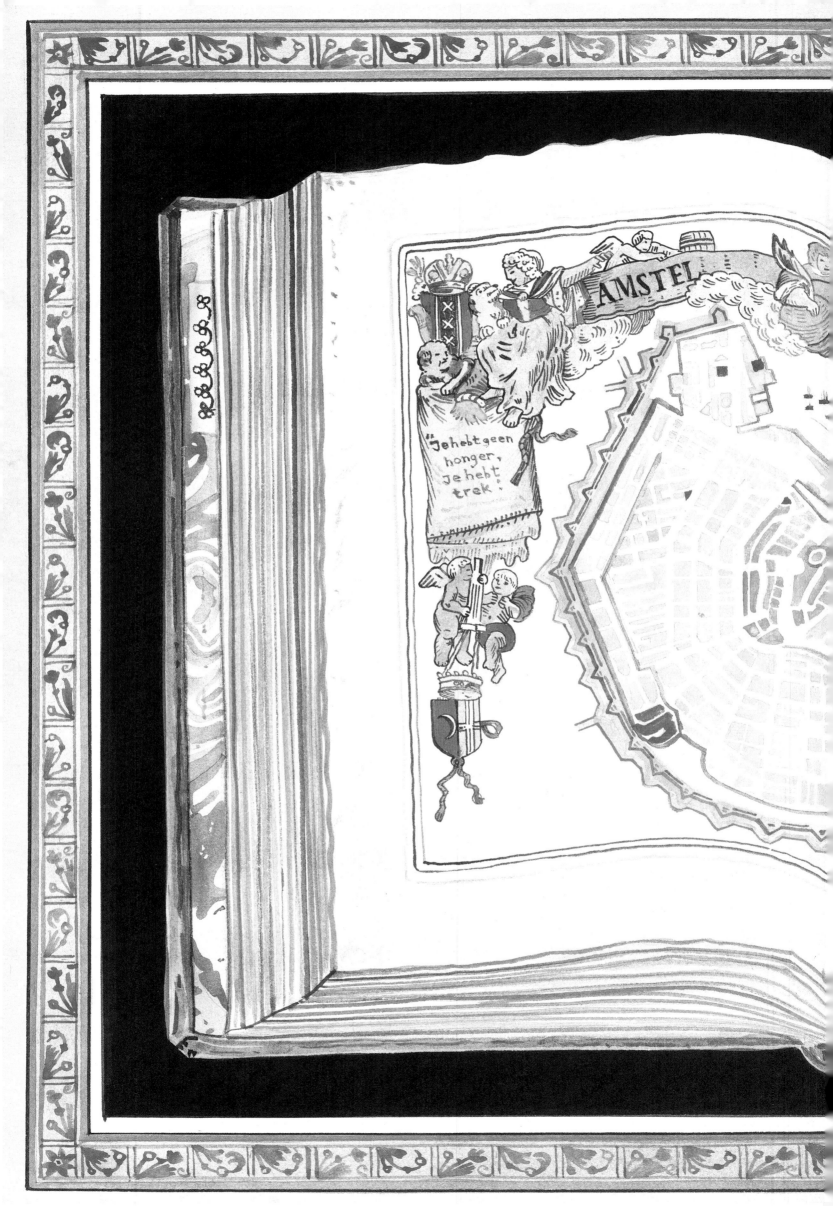

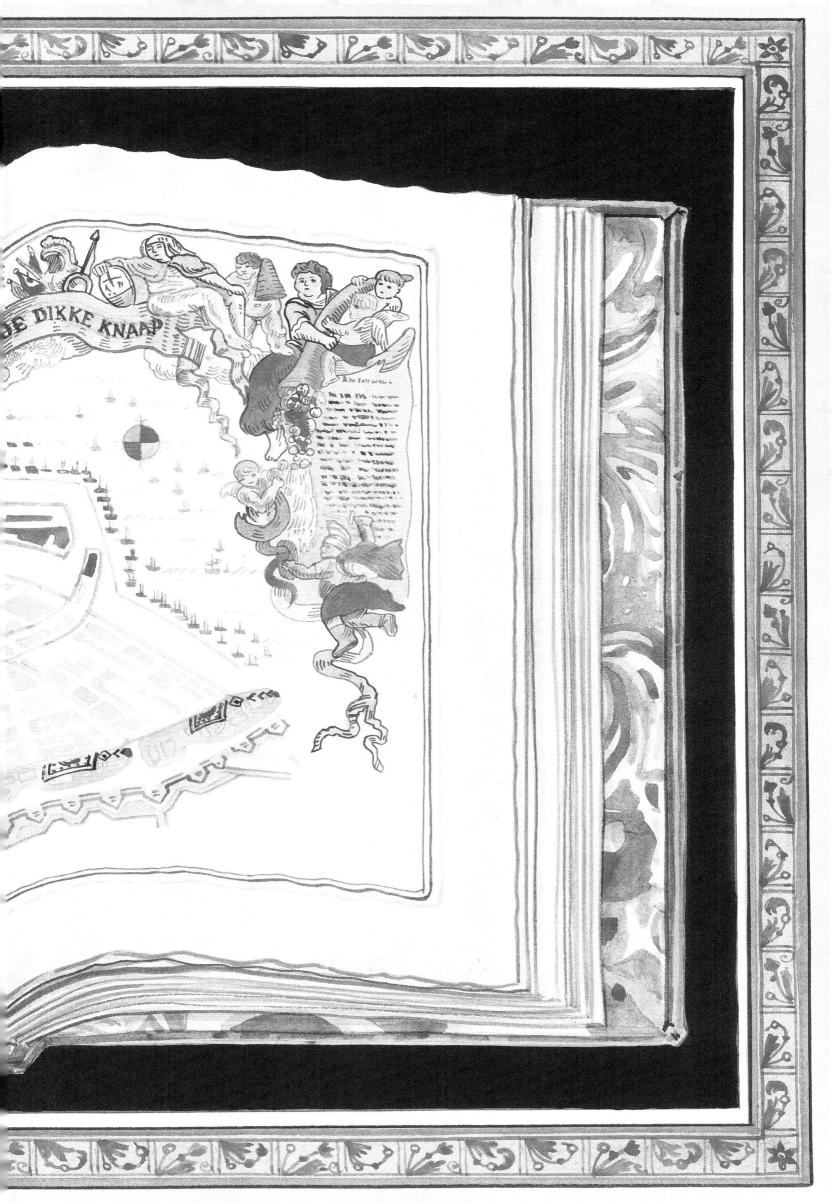

EDINBURGH
THE OLD CITY CARRIES THE NEW

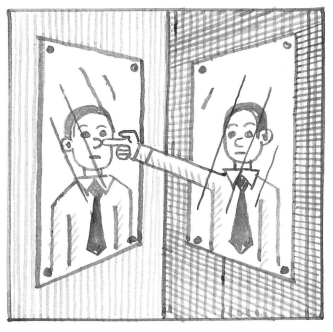

Having always existed on the map as an individual entity, some cities are surprised to suddenly find a companion city appearing by their side.

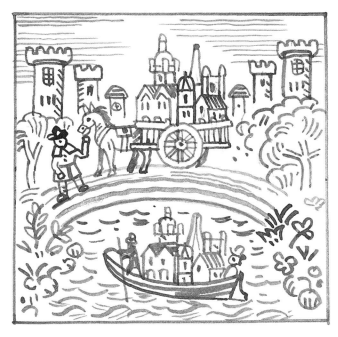

Unlike the many fluvially cleaved cities that grow from birth as two equal yet distinct halves, the second city in this case arrives as a young pretender.

Occasionally, two cities forced to share a common identity develop an antagonistic relationship, one of host and parasite, with the new city riding on the reputation and achievements of the old.

Depictions of such cities, possessing both the wisdom of age and the vigor of youth, can be positive or negative depending on whether this is a case of a young steed carrying an experienced rider or a novice on a nag.

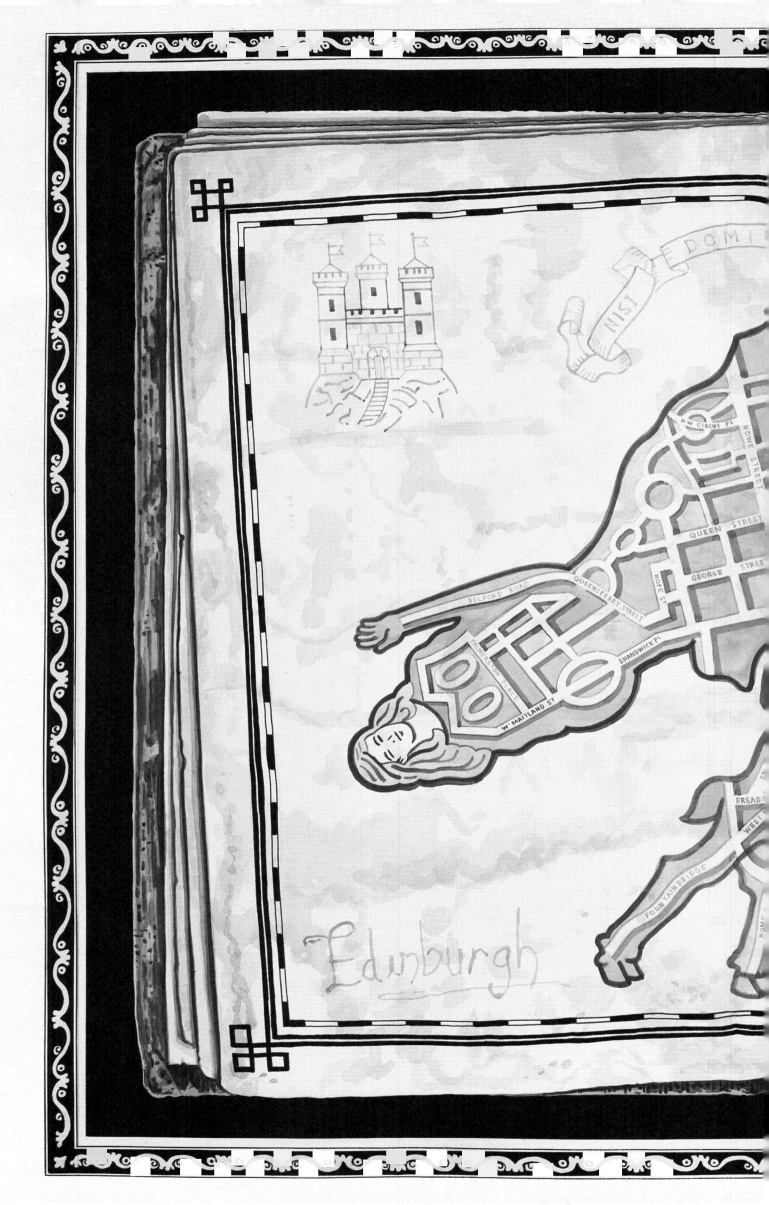

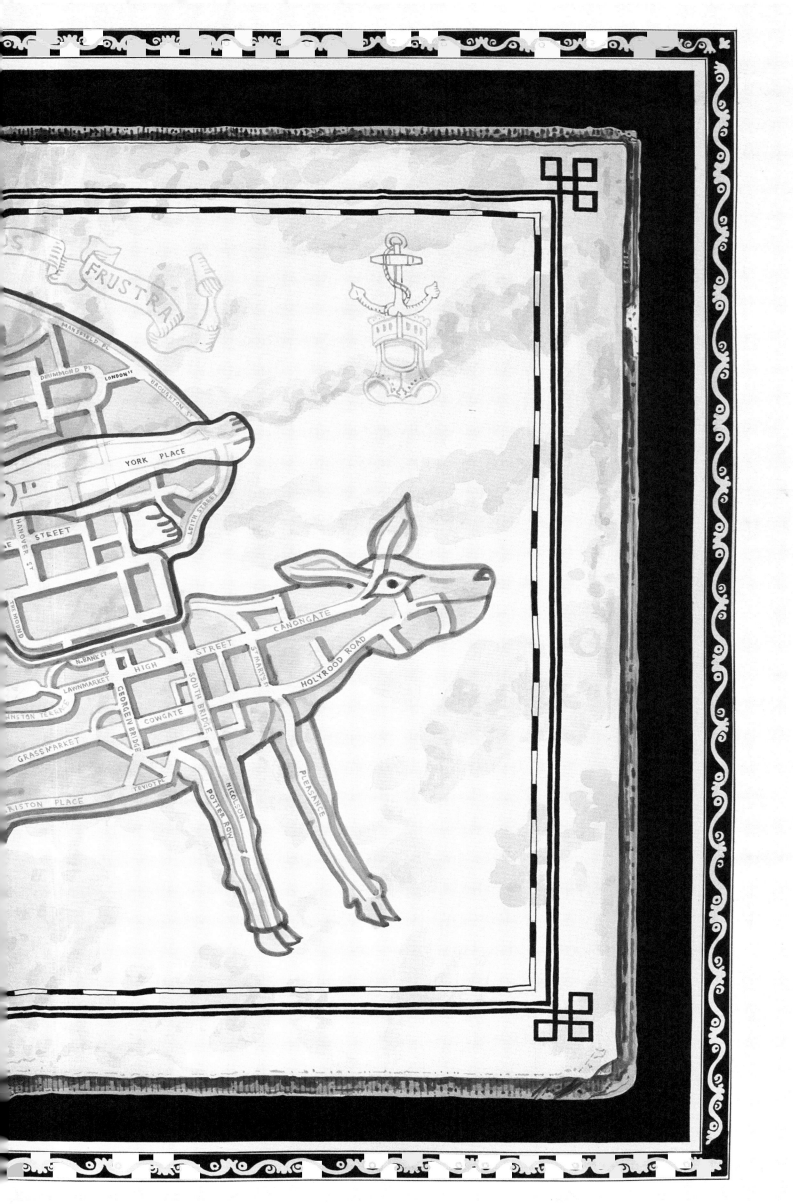

LONDON
THE CITY DIGESTED

Passage through the city as if through the human digestive tract allows for the identification of all the major organs en route.

The city is certainly spoken of as having a heart, lungs, and bowels. Perhaps the location of these major organs on the map might be of assistance in tracking down other organs, such as the city's spleen or its duodenum.

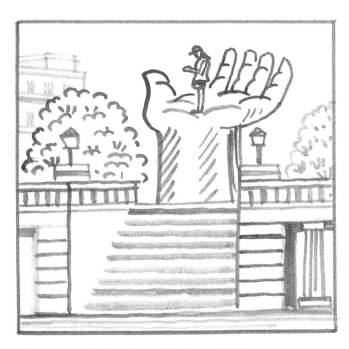

As an exercise in what might be called "corpo-geography," the identification of the city as a body elevates its citizens above their own tedious physical bonds to a place.

In addition, the health and general well-being of a metropolis might be identified, diagnosed, and treated so as to maintain good function and regular motions.

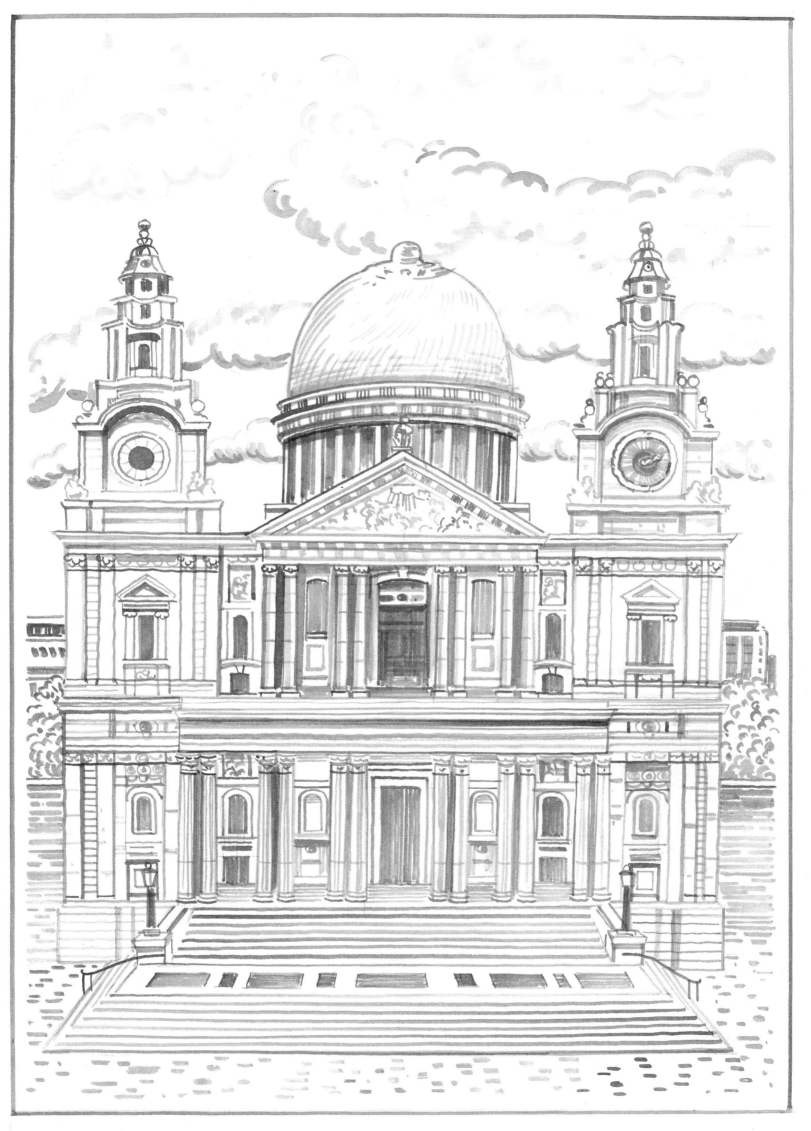

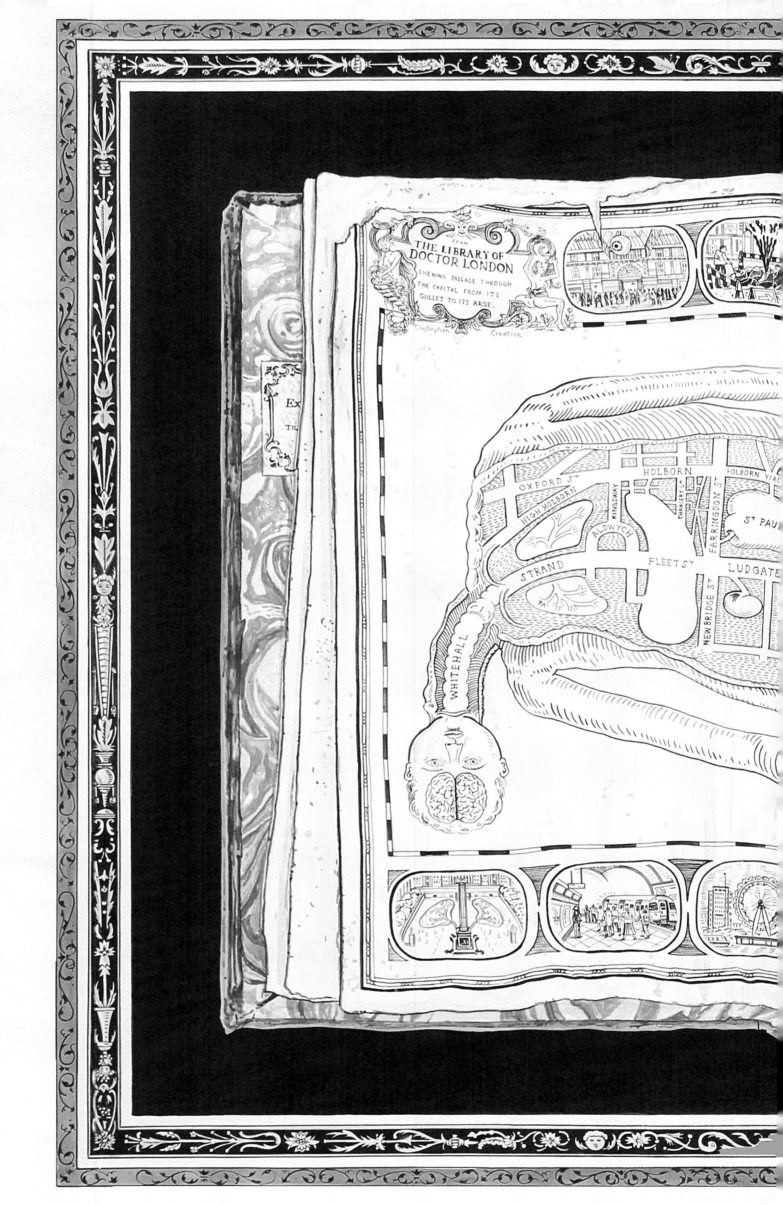

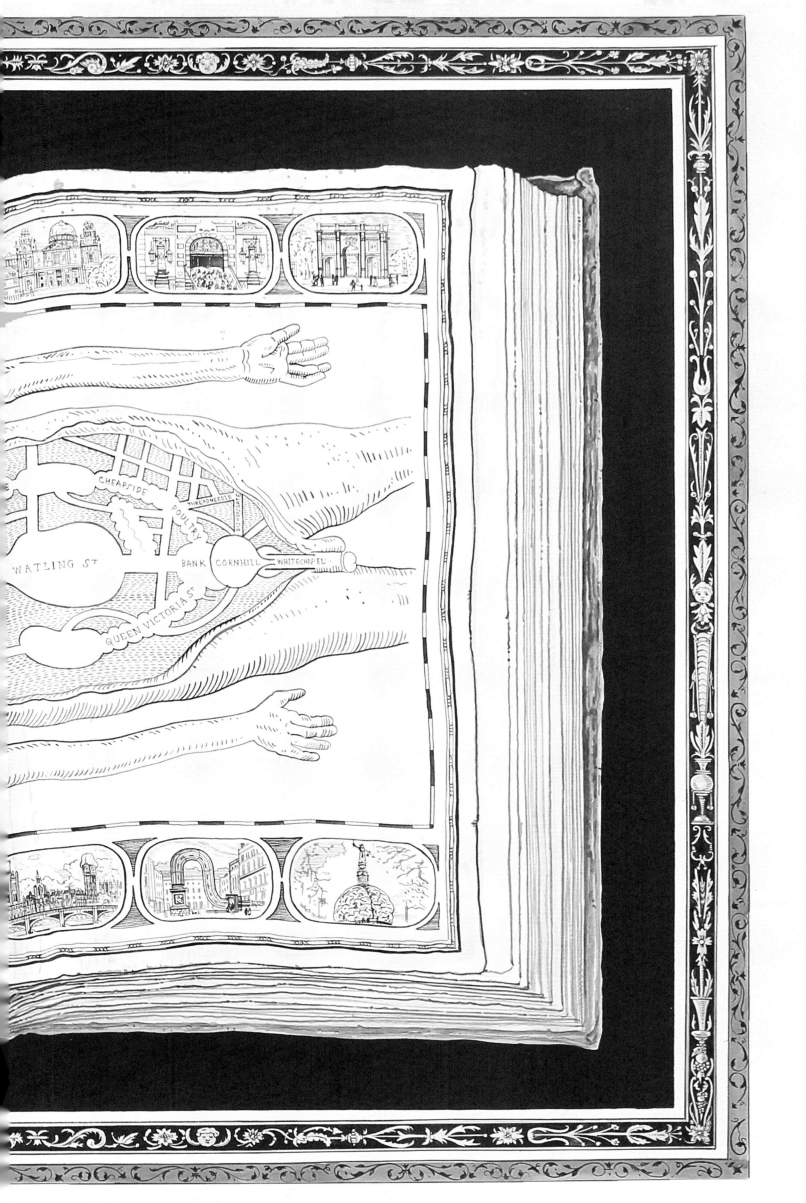

LONDON
THE CITY SQUARED

Why are we tempted to perennially reorder and rationalize our cities as if they had developed unexpected and undesirable physiques and needed a novel regime?

Apart from unusual examples where a city is born fully formed, or cases where conflict and disaster necessitate total, tabula rasa – led rebirth, "remodeling" a city often reveals more flaws than it does glorify ideals.

Bees may very well live in hexagons and serve as a model for society, but our purposes are ones of analogy rather than the production of honey.

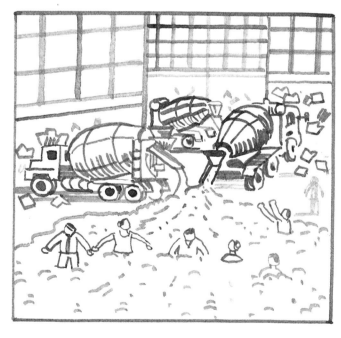

In the realm of the grid, citizens soon find the sharp corners of their city bashed and bruised, and its angles by degrees squeezed out of joint.

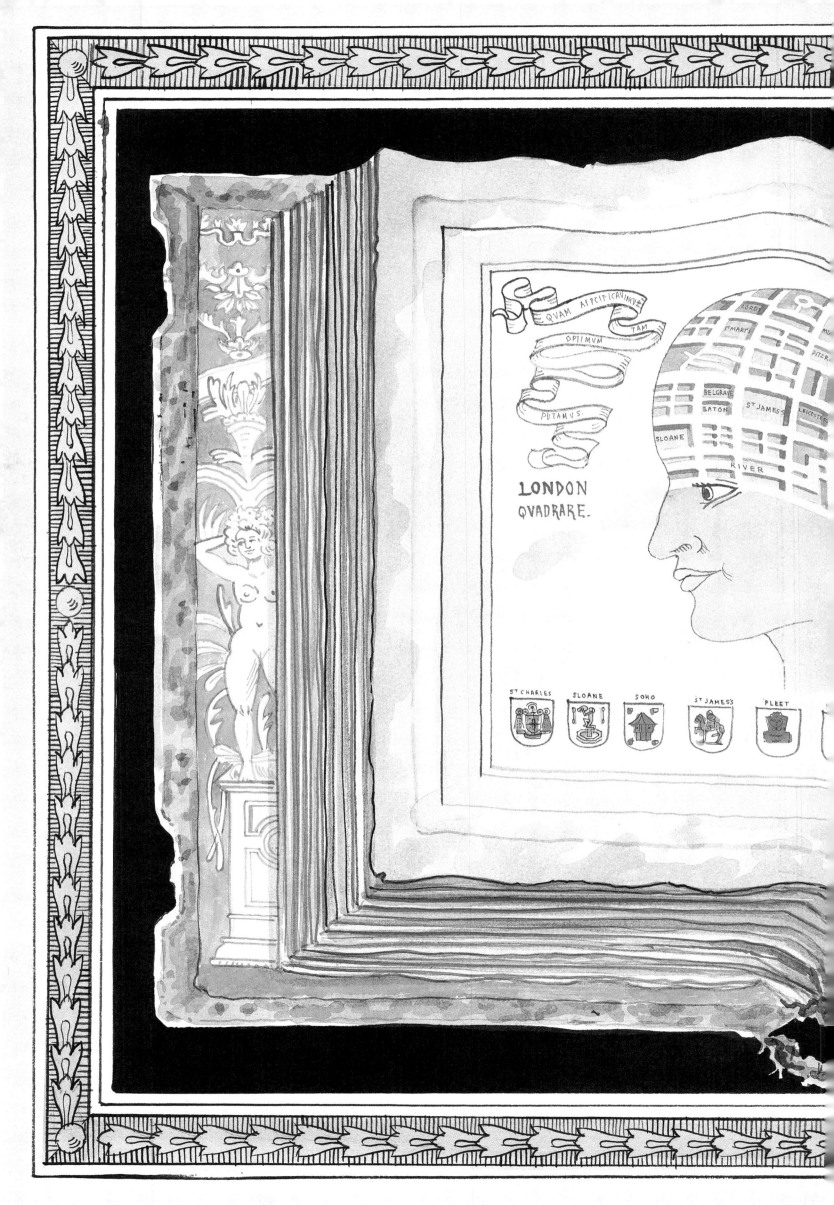

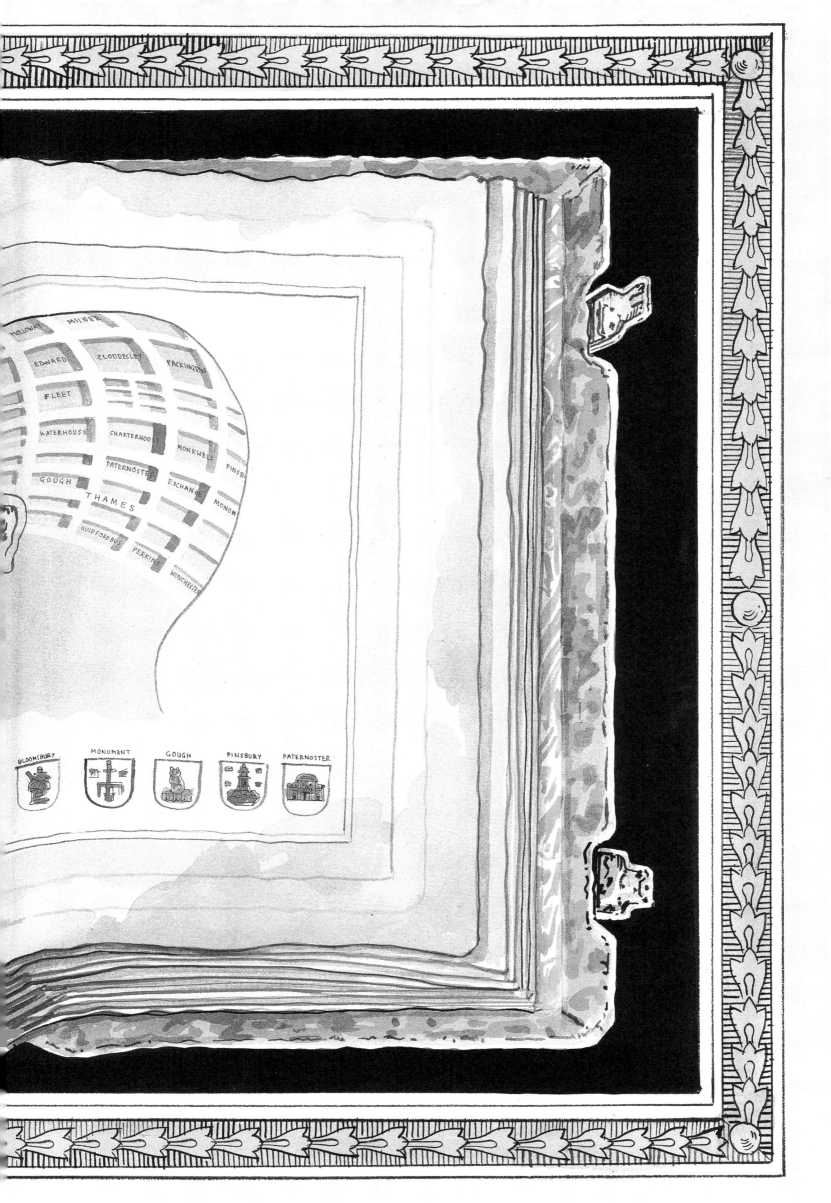

THE CITY OF LONDON
THE CITY'S FOUNDERS

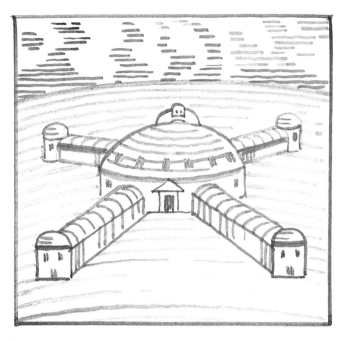

Describing the foundation of a city as its birth suggests that, at some point, the city was a baby and had an infancy, the episodes of which, like those of all infancies, can never be properly remembered.

The creation of myths to fill this significant vacuum leads, most importantly, to the cohesion and self-identification of societies.

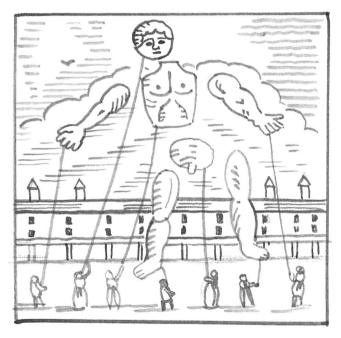

Such myths are crucial in the personification of a place.

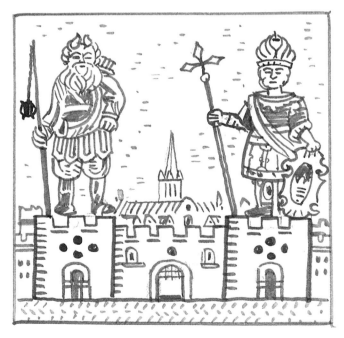

It is citizens' willingness to cleave to these myths that has seen figures such as Romulus and Remus in Rome or Gog and Magog in London becoming ever present icons of quotidian urban existence. The identities of these myth-ical founders coalesce through time until the cities bear their resemblance.

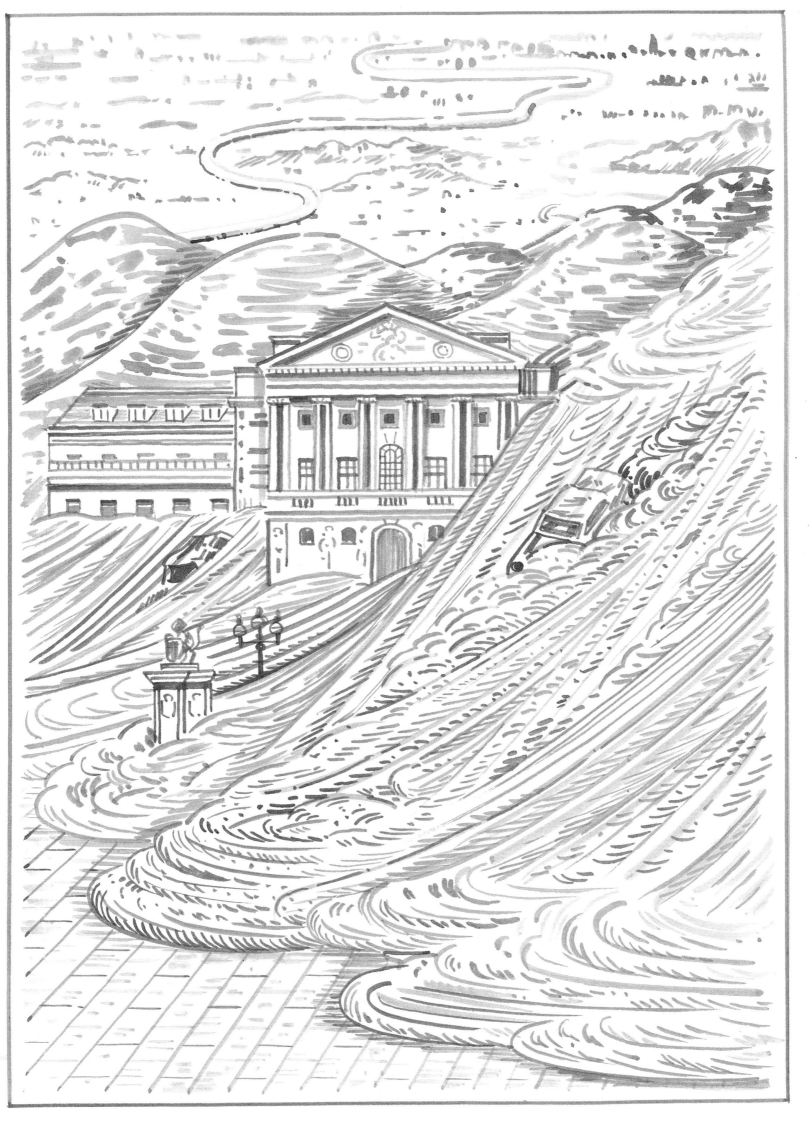

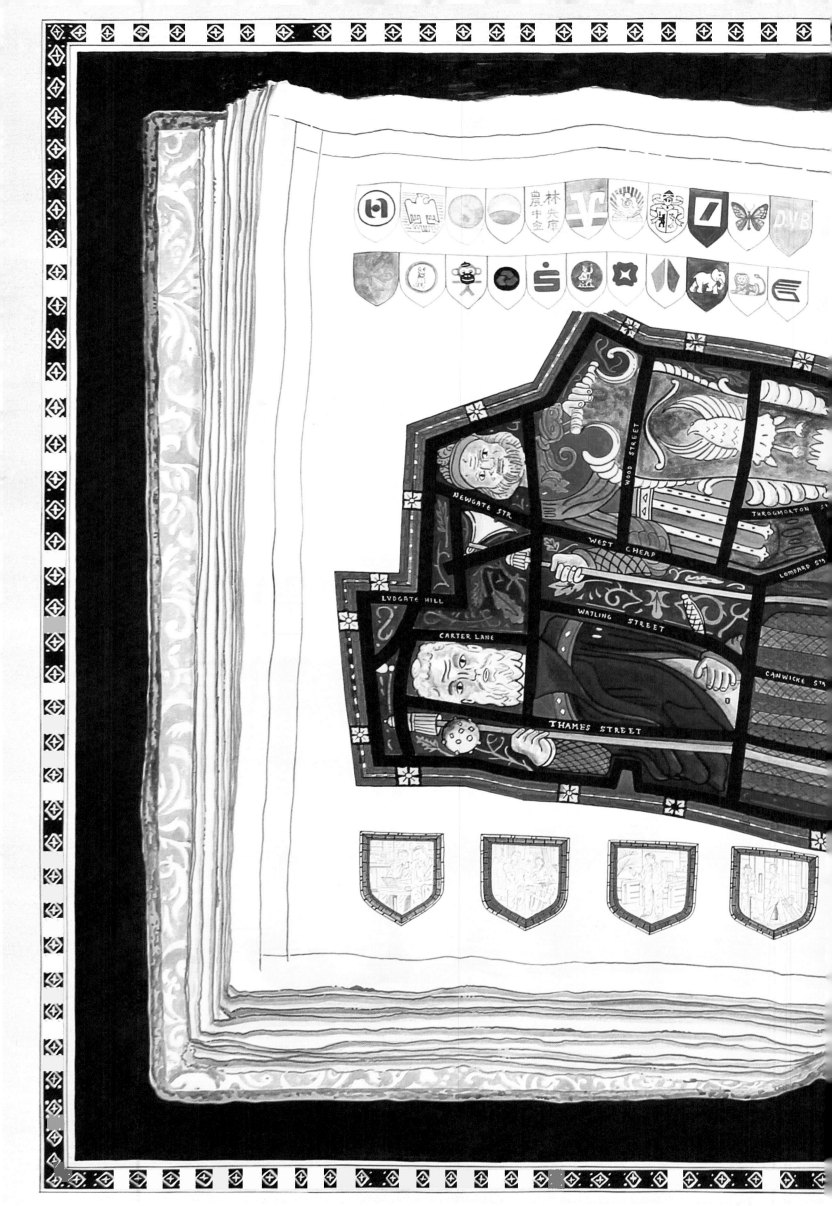

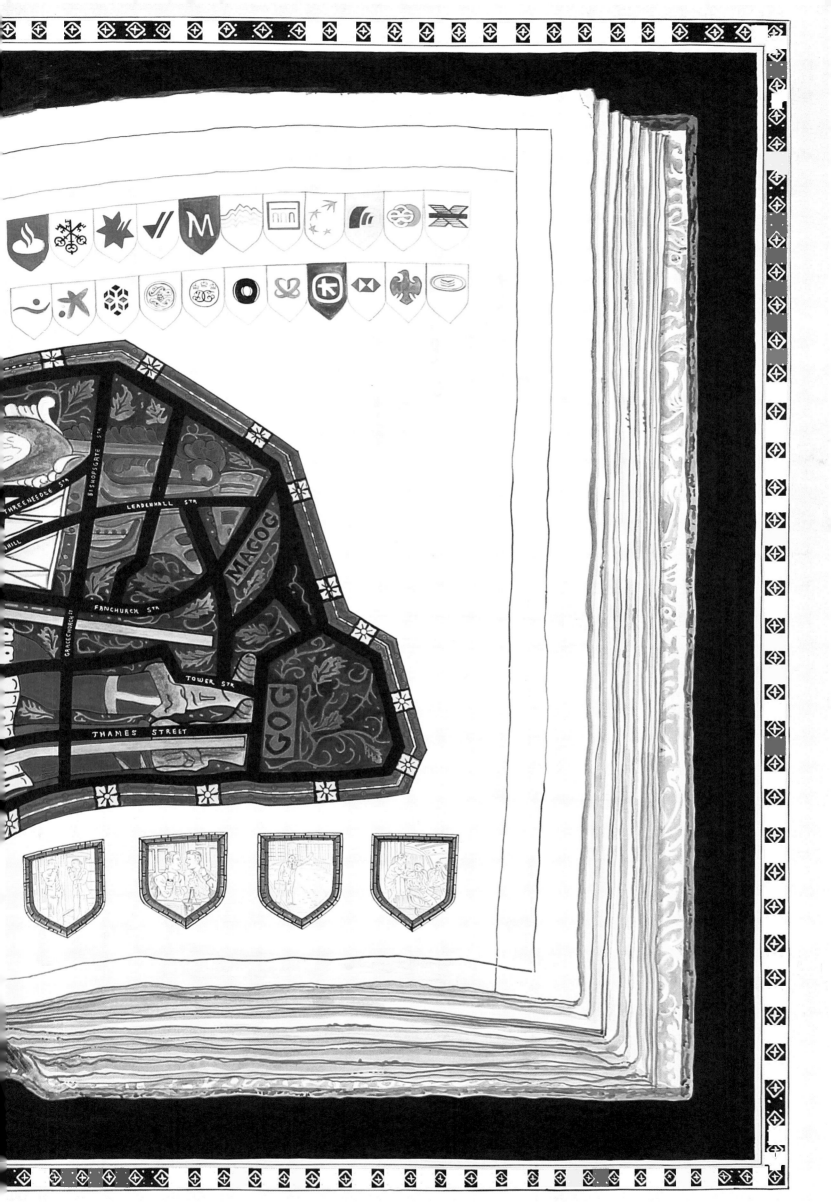

MONACO
THE CITY AS MUSE

Cities have provided the inspiration for great art and great literature. Personified, such cities assume the qualities of the muse, exuding enigmatic beauty and timeless allure.

The muse's particular qualities lead to other forms of devotion, in addition to the production of poetic art. Great beauty always finds a fool to provide material enrichment, in a contract as timeless as both archetypes.

A marriage between attractive prospects and mounds of lucre, embodied as a work of art, creates an image of the muse unlike conventional representations of beauty. She (the city) is an "investment," reduced to an inventory of randomly distributed but covetable regions.

Consequently, the idea of the city as muse is rendered as a three-dimensional list of essential "bits," which can be seen from all angles by all viewers simultaneously. However, despite the total exposure of the city's "goods," this city remains the plaything of the other half, flagrantly displayed but forever unavailable.

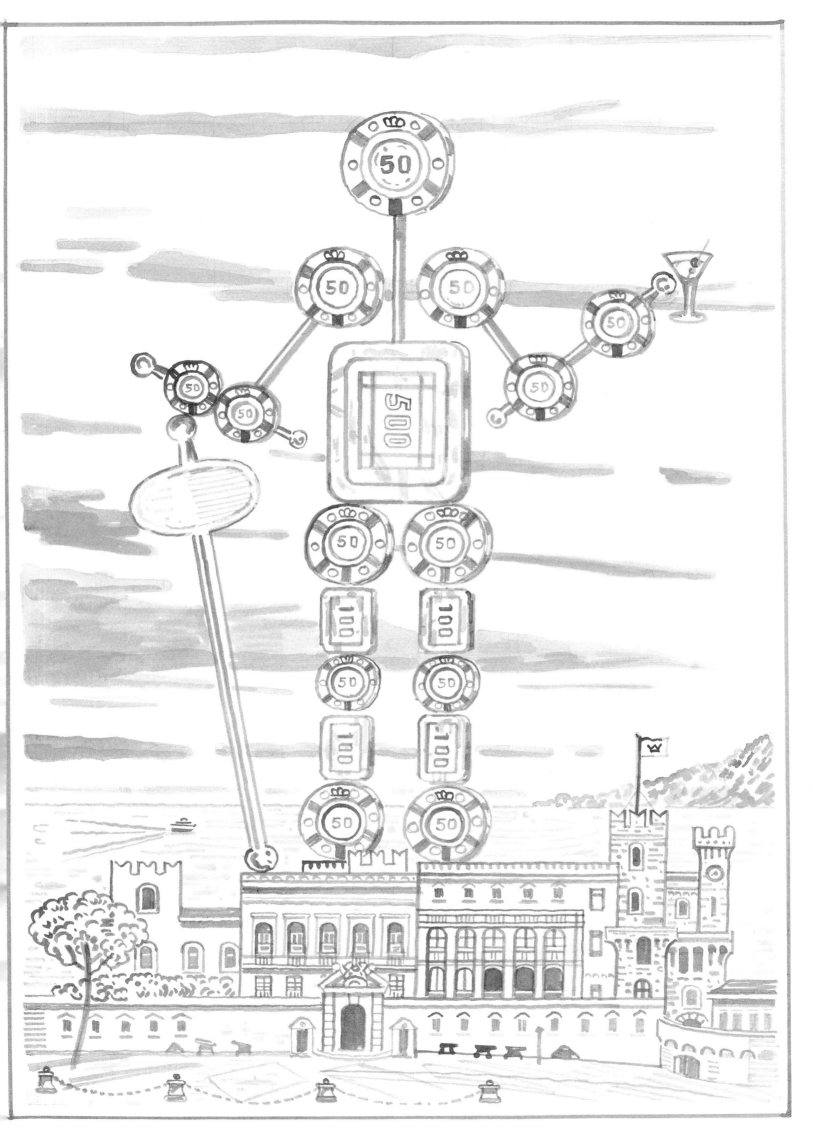

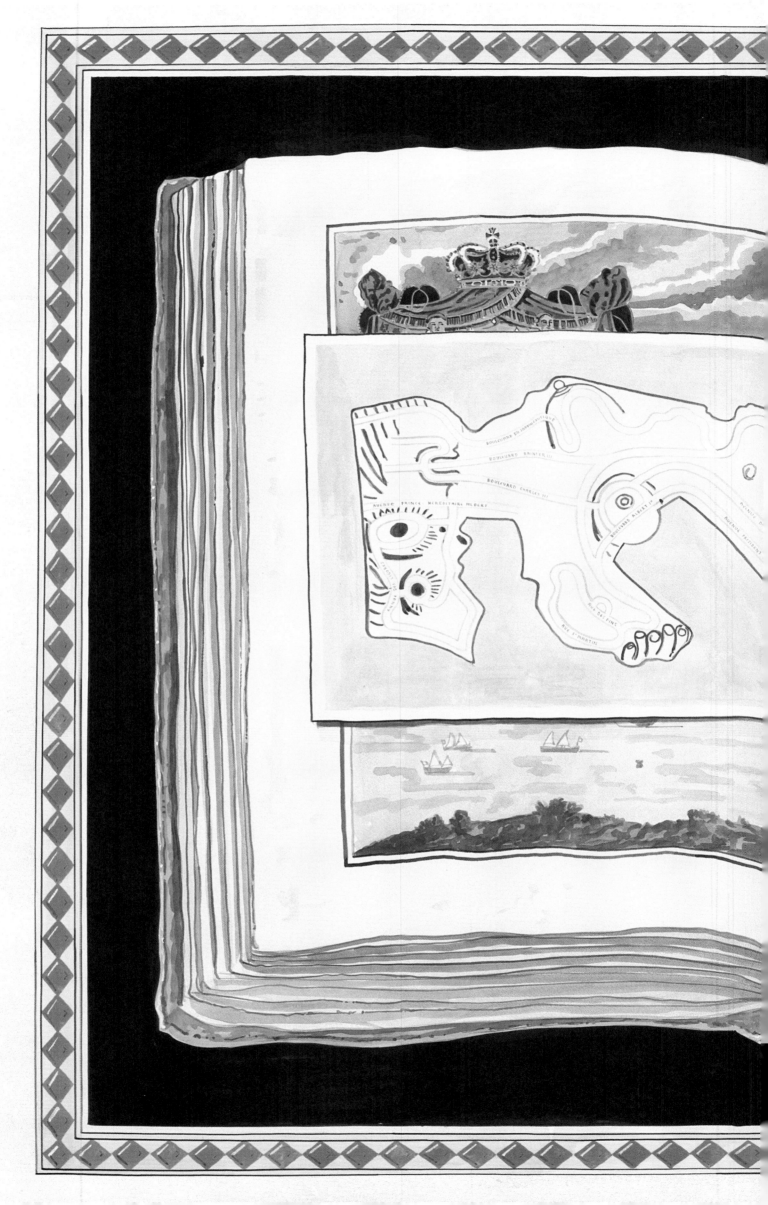

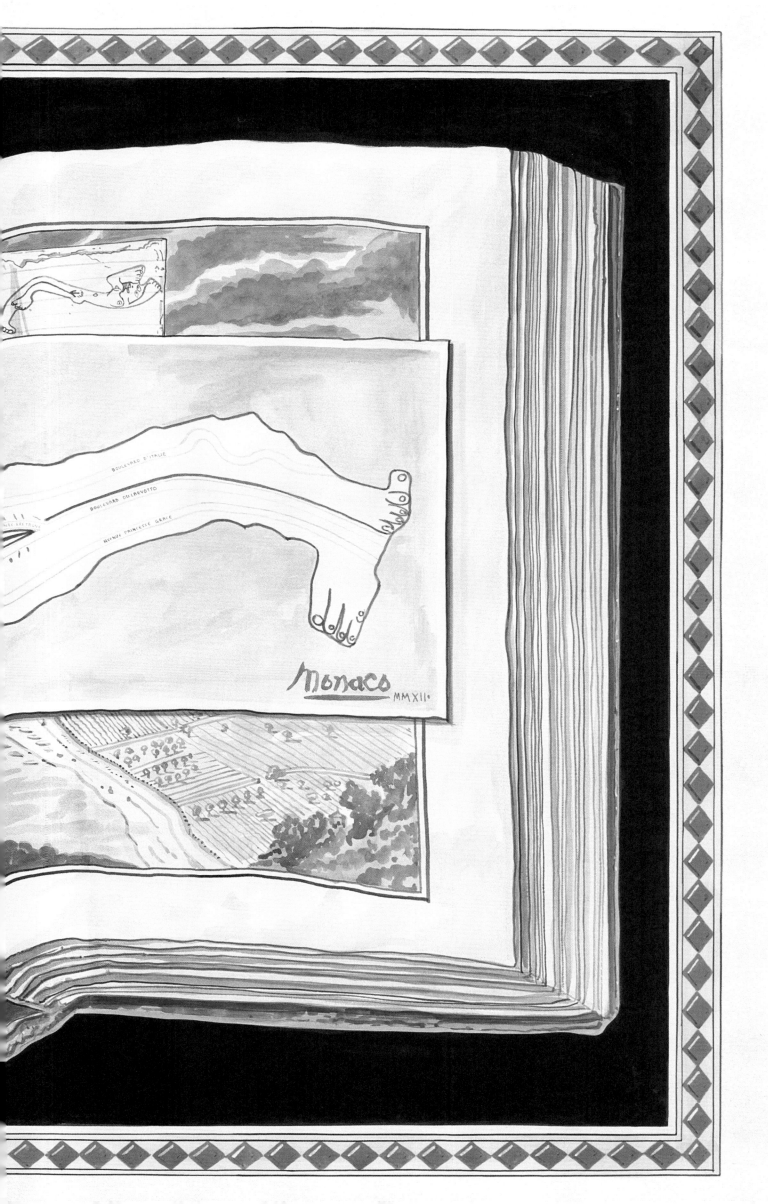

Monaco
MMXII.

LAGOS
THE MOVABLE CITY

It is easy to imagine the city archipelago personified, disentangling its component parts, organs, and limbs from one another, drifting to new climes, and reassembling itself, the same city but elsewhere.

The occupants of such a peripatetic, "floating" city often seem to carry a lot of stuff.

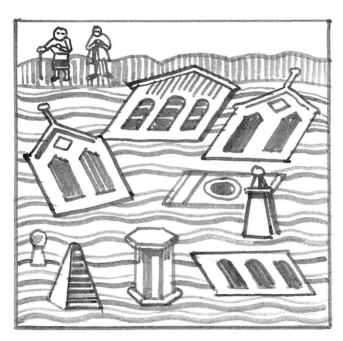

Just how much a city is comprised of this baggage—all the stuff that is not bolted down and can be dismantled and borne across distances—is a vivid manifestation of the city as an organism.

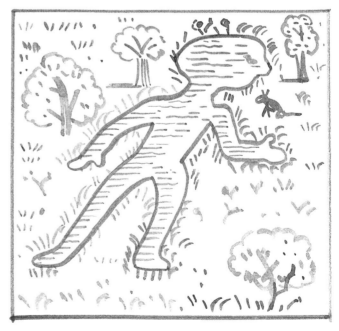

The city as a settlement of people and things in a place is thus a proposition distinct from the city as a place in and of itself.

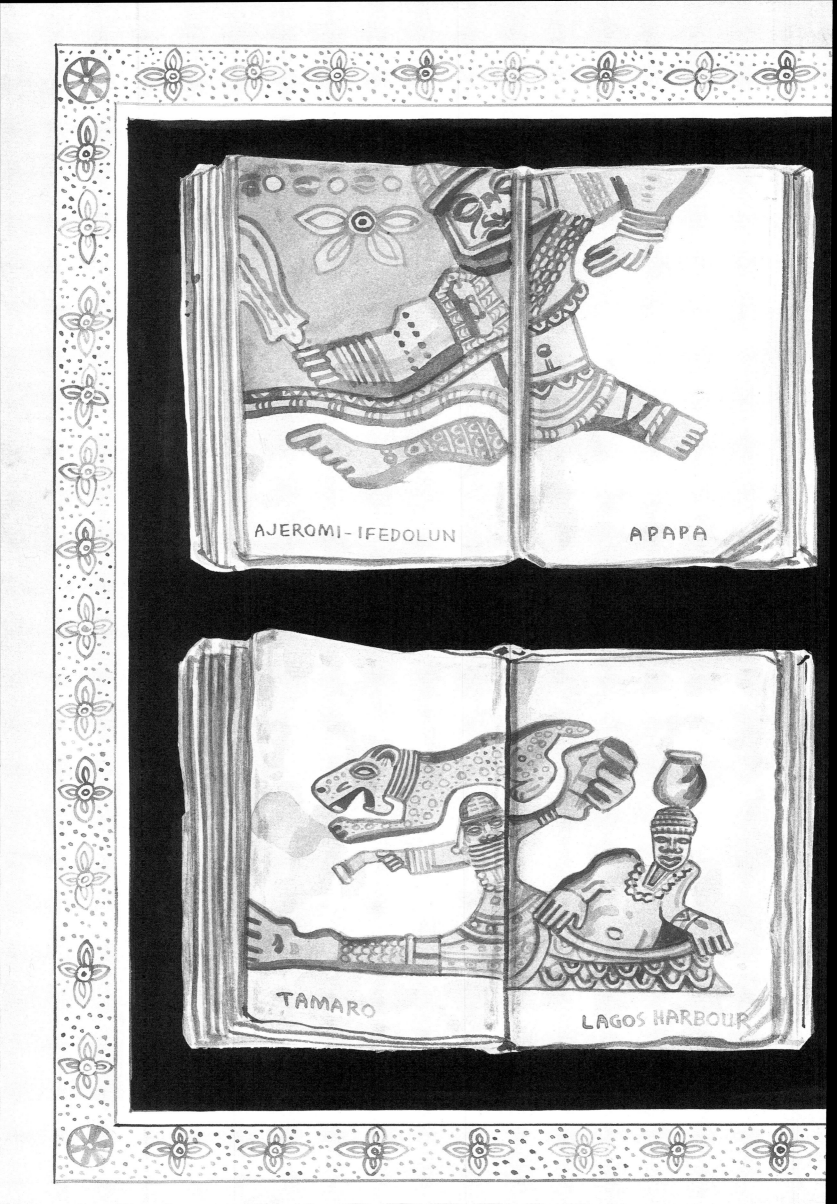

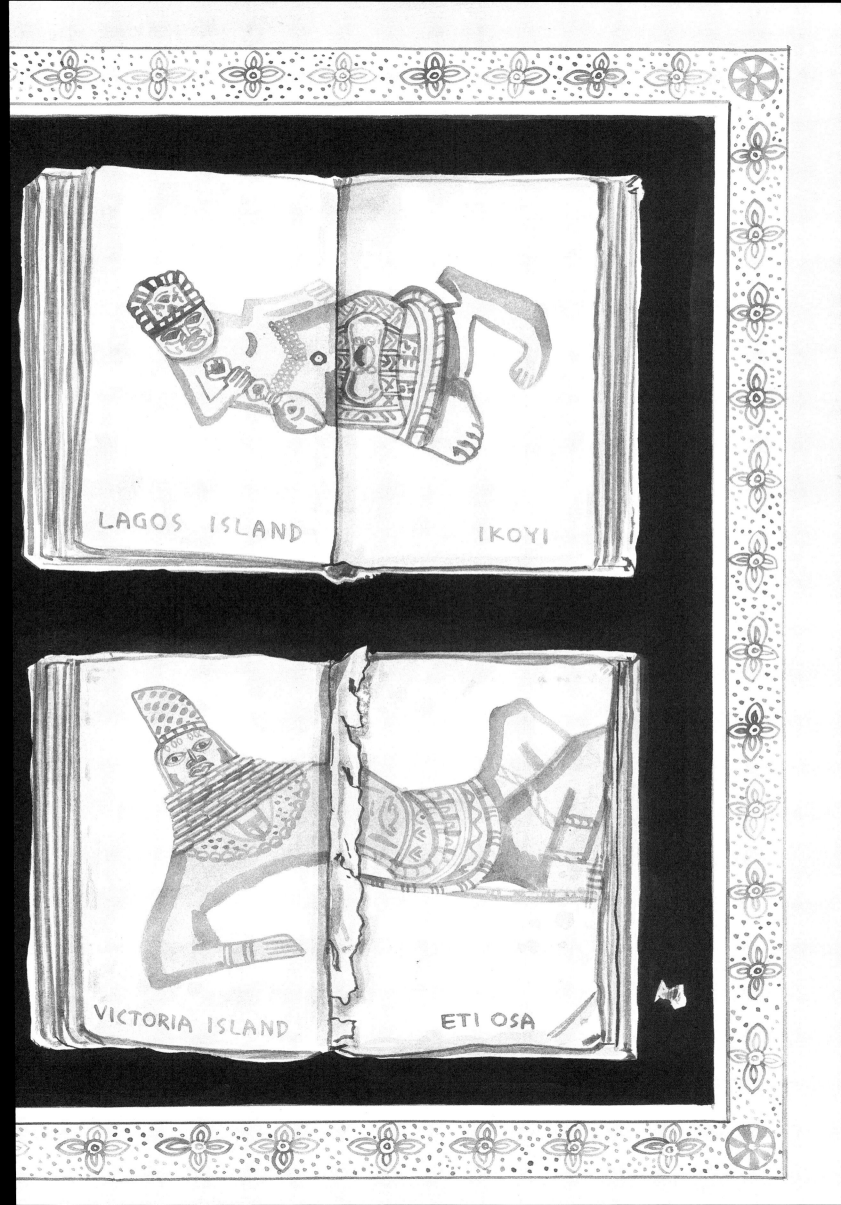

MUMBAI
THE CITY AS THE BIG FISH EATING THE LITTLE FISH

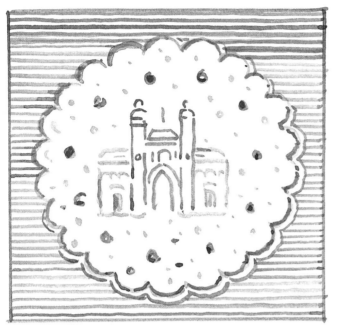

The parent scolds the child with the caution, "If you eat one more biscuit (or plum, peanut, etc.), you'll turn into one." In much the same way, the city might come to resemble that which nourishes it.

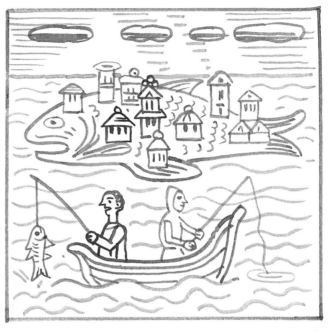

The point at which this resemblance forms is also, as the city expands, the point at which identifying the city according to its nascent source ceases to be relevant.

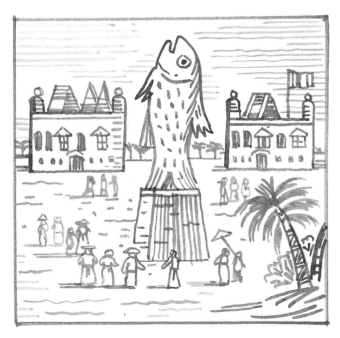

An apparition of the city's founding spirit is often only discernible once the settled and continued existence of the city has been assured.

By this time, reserves of that which first nourished the fledgling city have usually dried up, necessitating the creation of new cities to maintain supply and sustenance.

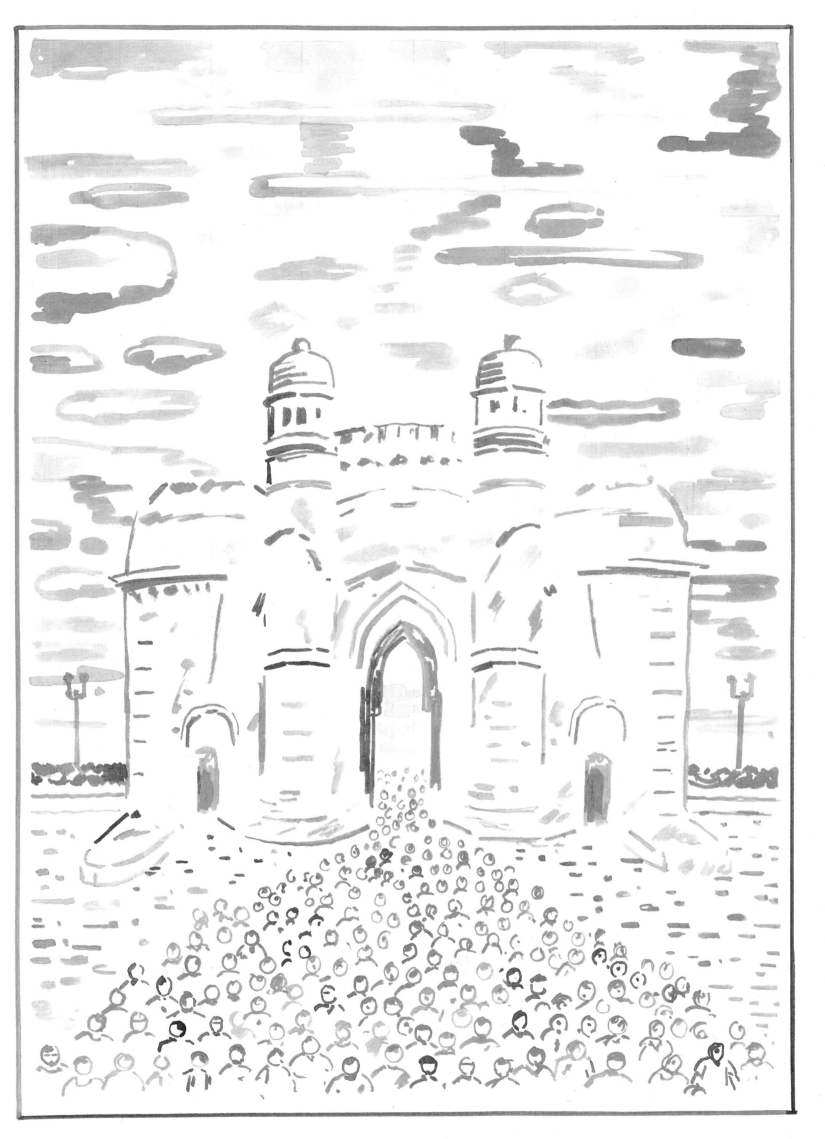

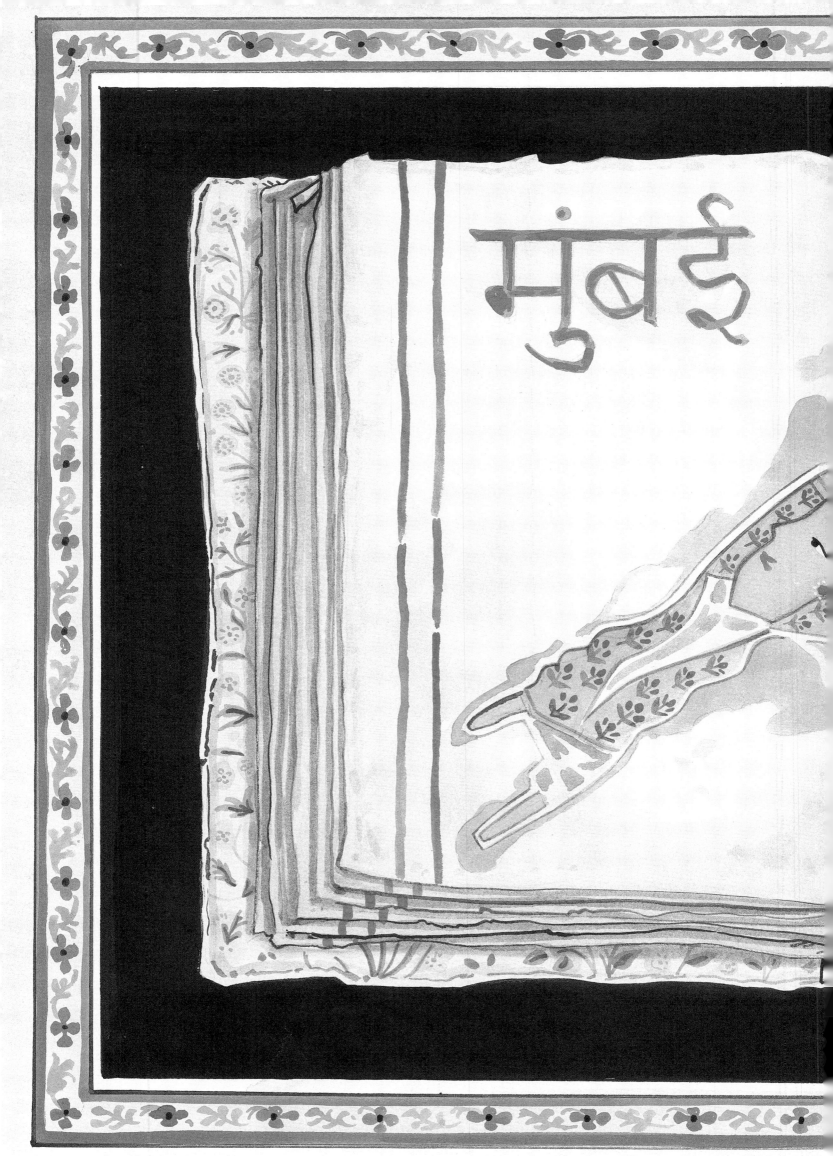

BEIJING
THE CITY COMMODIFIED

In the midst of a hyper-consumerist age, and with "the market" preeminent above all else, describing a city as "forbidden" might be seen as the ultimate marketing slogan.

Finding itself in an arena where everything is commodified—not just available but flaunted and proffered at every opportunity—the forbidden city is suddenly the most desirable of destinations.

As long as whatever is forbidden in the city remains in the box, unopened and unknown, unwavering interest in this will supplant interest in all else.

Inevitably, however, a city that exists solely for the purpose of having or knowing something, the having or knowing of which immediately invalidates its existence, will suffer the same fate as a place where everything can be had and known.

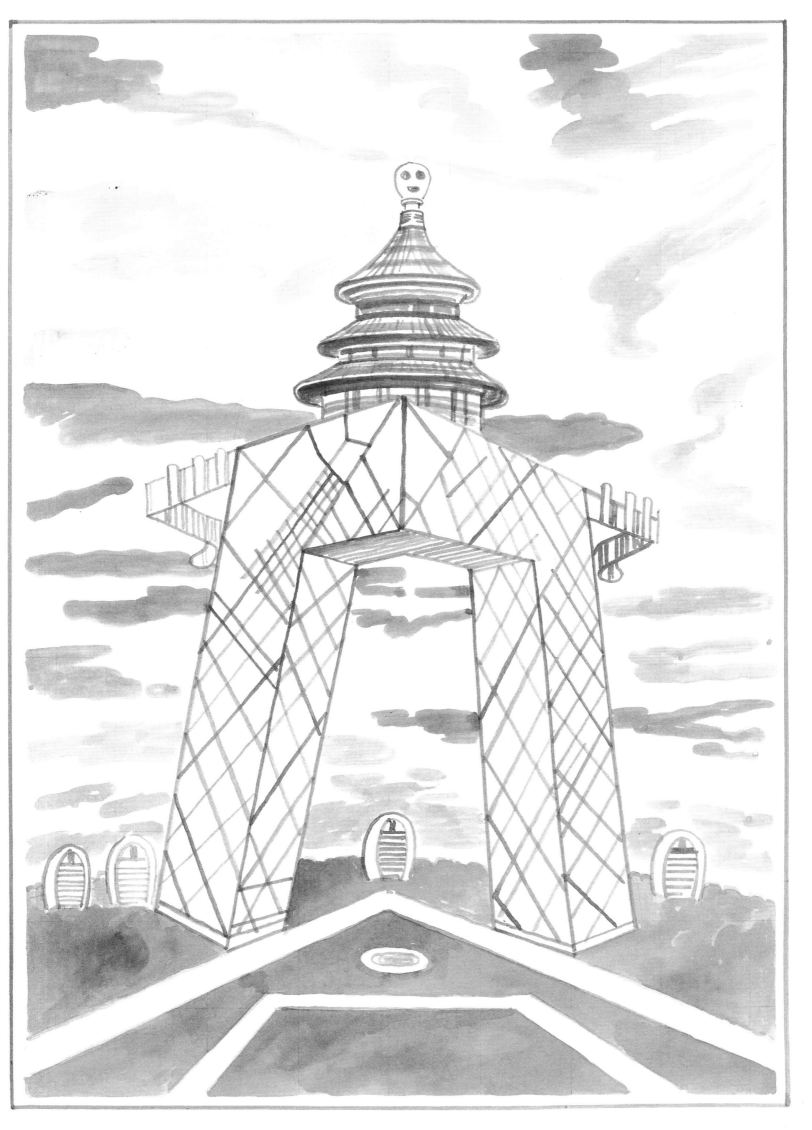

HONG KONG

AN OLD CITY IN A YOUNG BODY

The physical manifestation of a youthful and thrusting city, in thrall to a philosophy that favors the wisdom of elders, might look like nothing more than the interplay between puppet and puppet master.

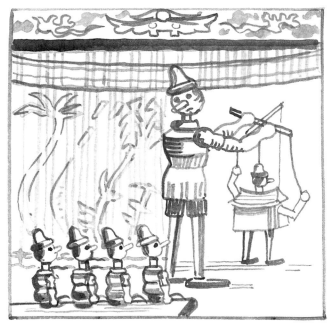

Does the world witness only the jerky progress of the former, or can it appreciate the deft control and skill of the latter as a part of the show?

Experience would have us believe that the puppet that cuts its own strings rarely leaps back up, flush with a life of its own.

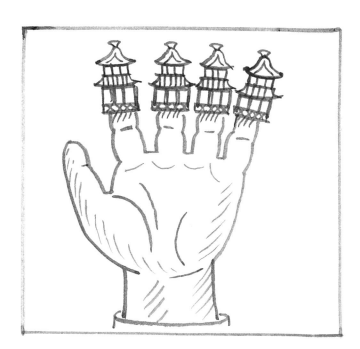

Nonetheless, this analogy of the city as a doomed marionette of the stringed variety still leaves hope for puppets of glove, shadow, and finger.

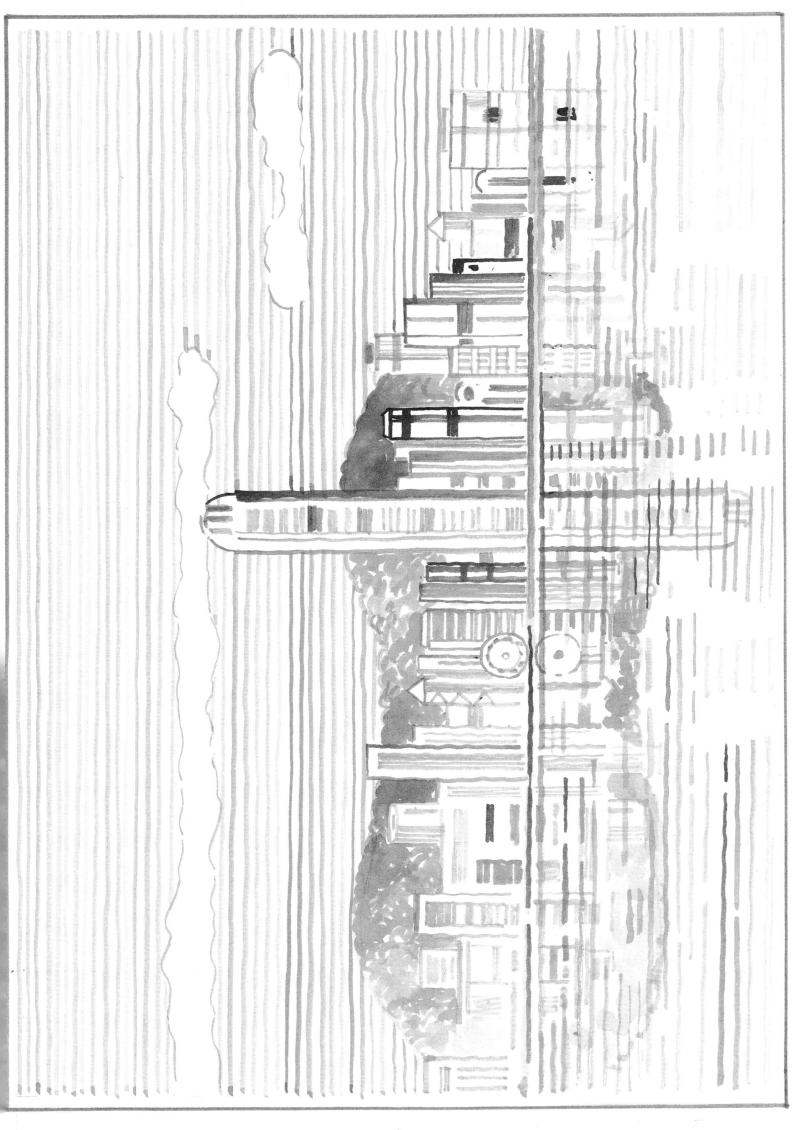

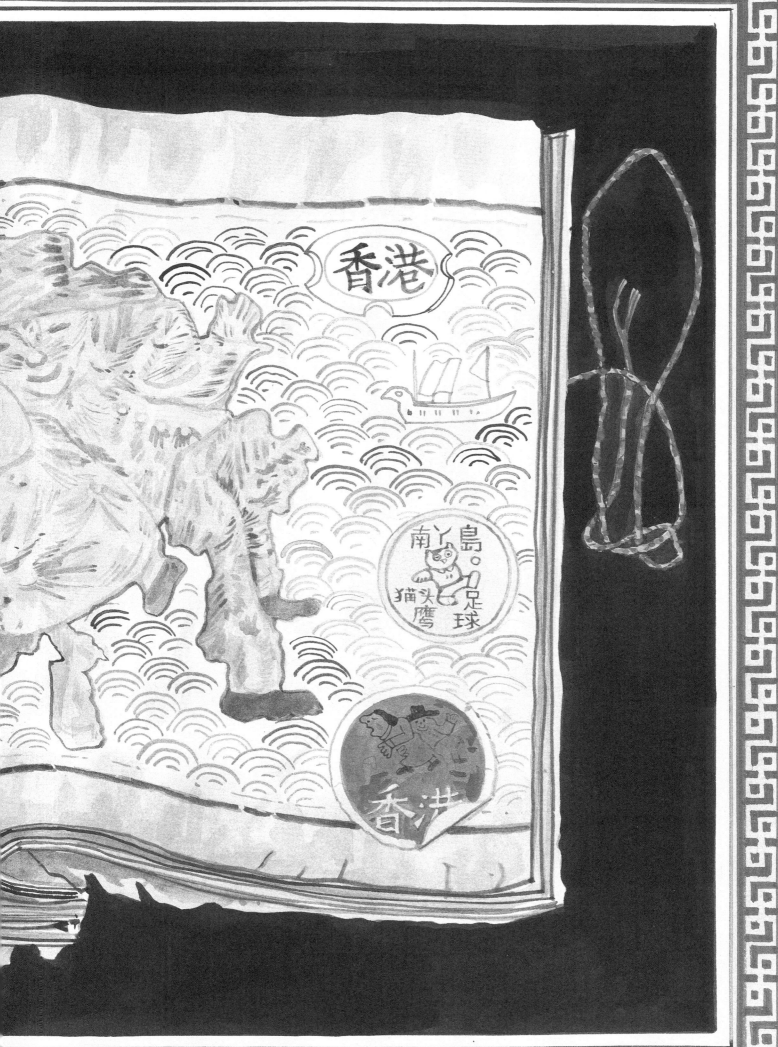

TOKYO
THE CITY IN A STATE OF PERPETUAL CONCEPTION

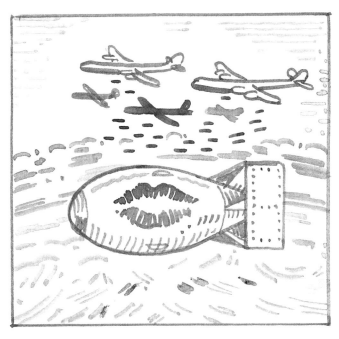

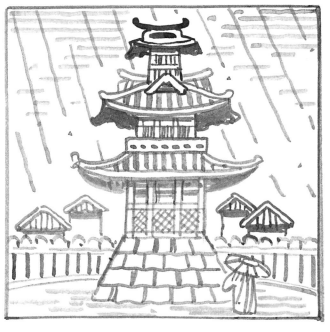

Cities may fight each other, but do they also fall in love? Is there an amorous equivalent to the act of one place sending down a rain of fire and venom on another?

During conflict, the taut, pent-up aggression of a place is palpable. Its raised hackles manifest themselves in stony defensive features, hefty ramparts, and impenetrable bulwarks.

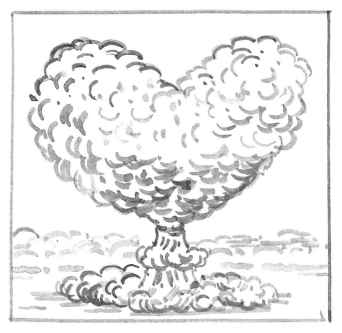

Realizing the antithesis of a city at war might see the perfuming of boulevards, the stripping off of restrictive cladding, the raising of the drawbridge, and a shuddering felt through the cellars of every household.

In their most desirous form, cities of love or cities of peace, like promised lands, nirvanas, and utopias, are enjoyed most tangibly in the clouds. A city of dreams formed from swirling vapors appears for a fraction of a second as a reality.

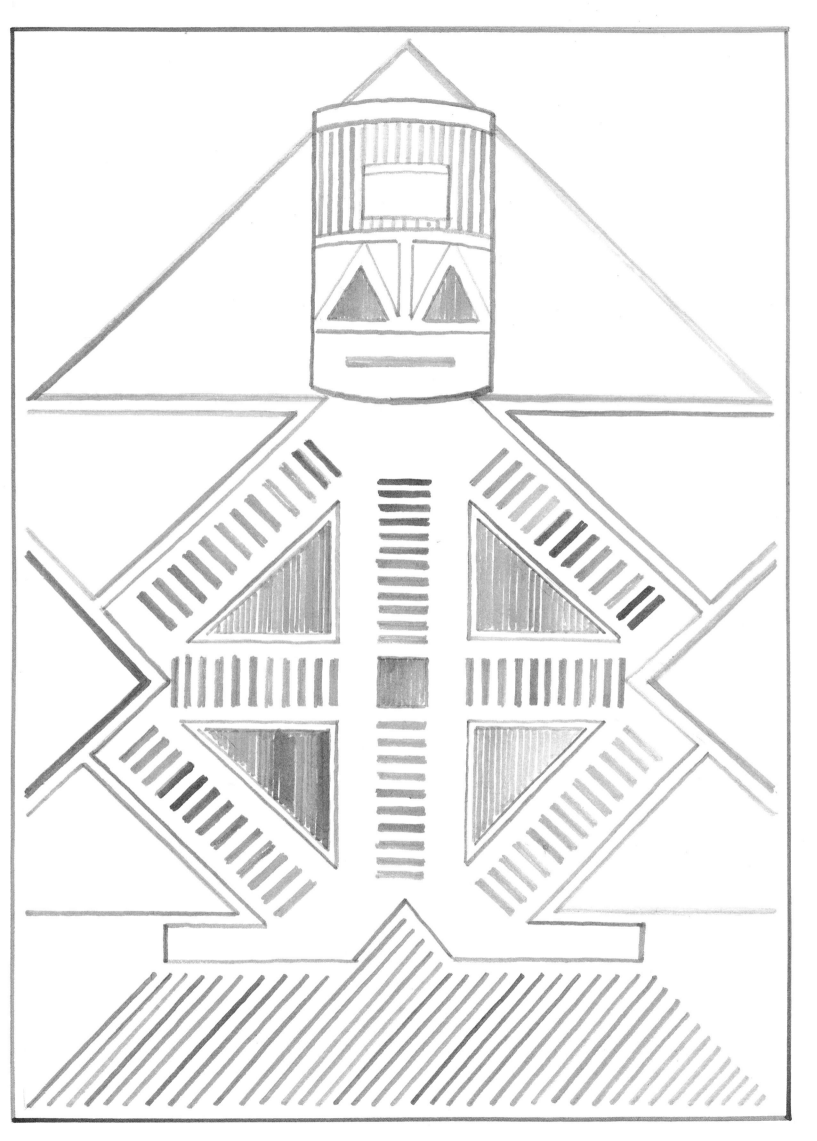

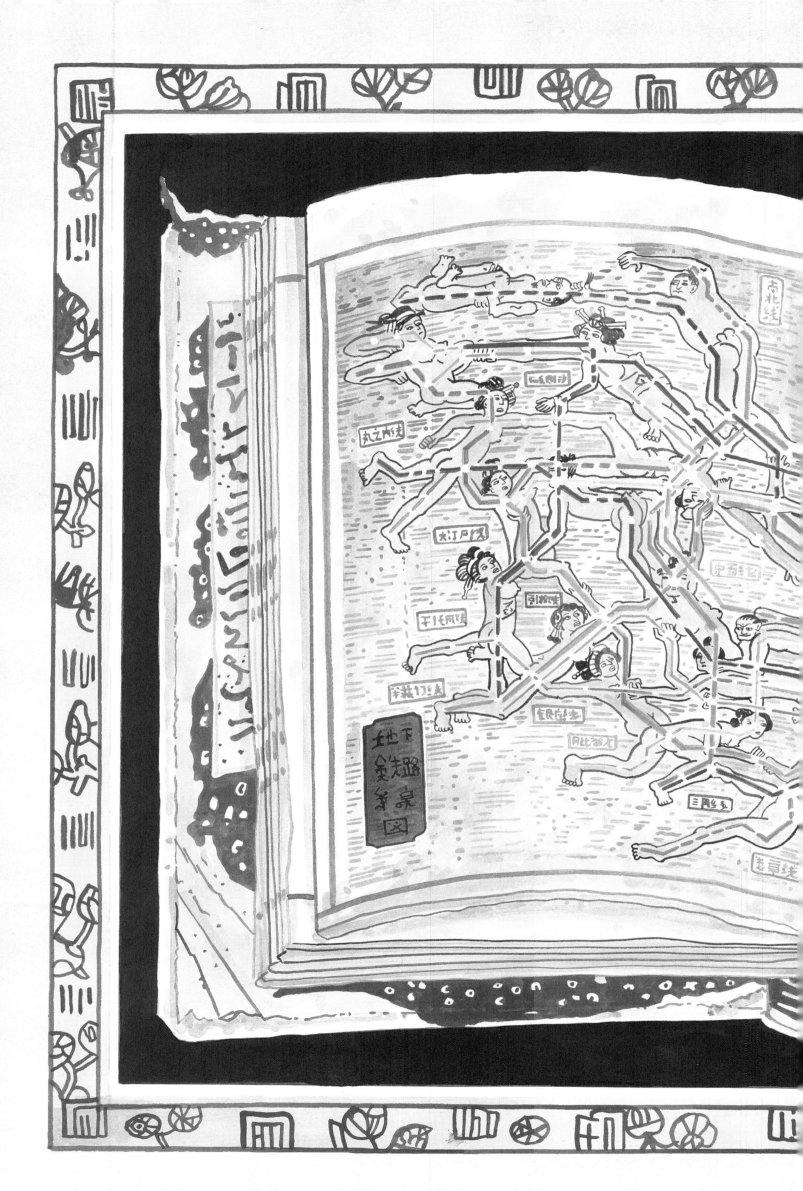

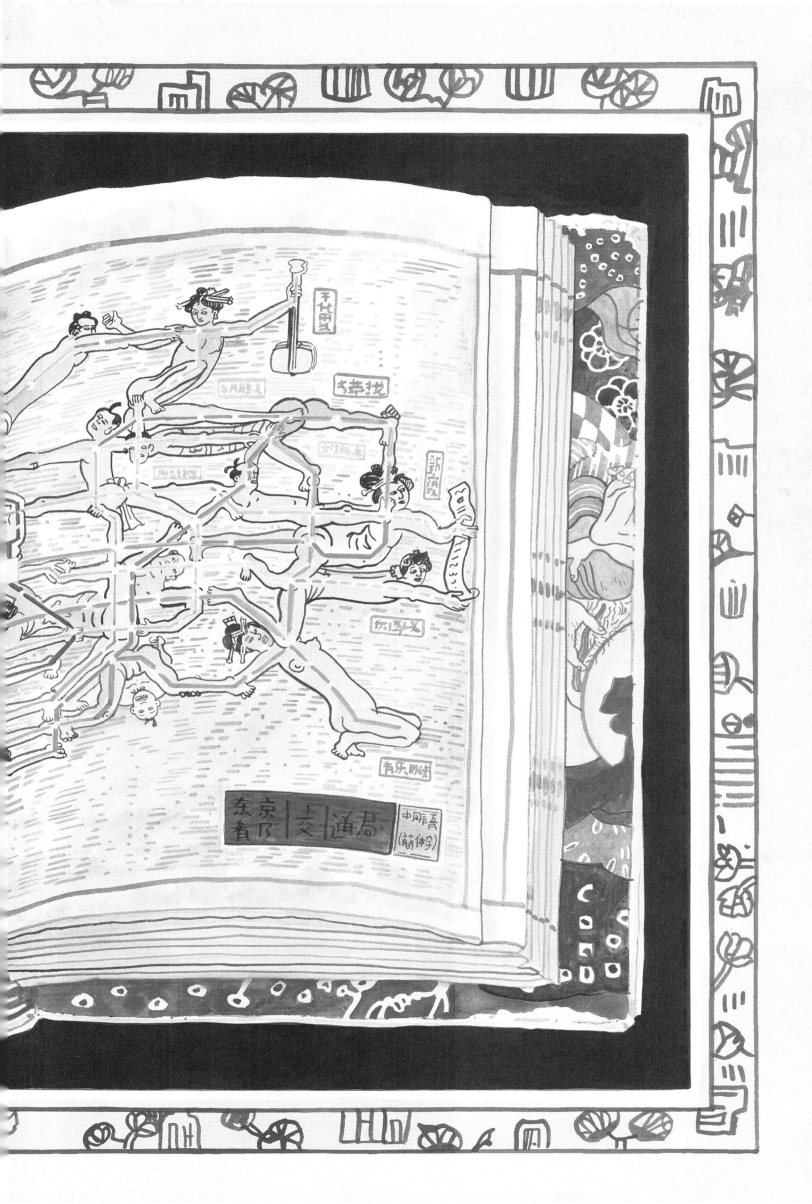

SYDNEY
CITIES IN THE MIRROR

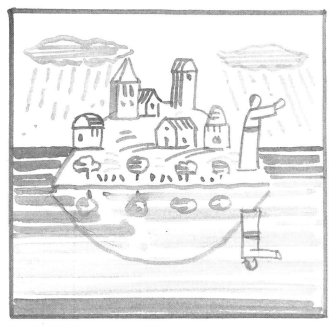

A guiding principle of the notion of "the city incarnate" is that cities might grow to resemble the citizens who shape and are shaped by them.

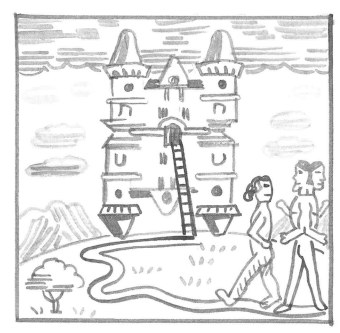

The city incarnate does not constitute a mirror image of its citizens, but rather an inversion, the reflection being flipped top to bottom as opposed to left to right.

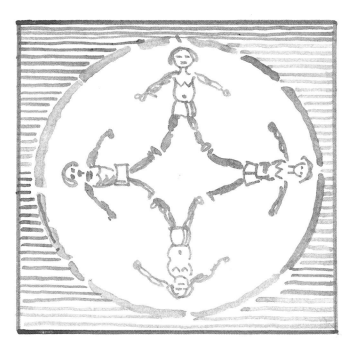

This visual concept is borne out in the physical relationship of citizens to their environment, the ground plan of the city mirroring the activities that happen upon it.

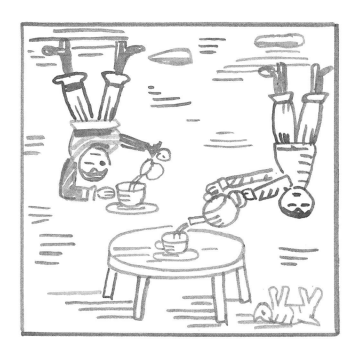

Such mirroring is regularly contrived to exist on a global scale, as we often imagine citizens on the other side of the world going about the same business as us, but upside down.

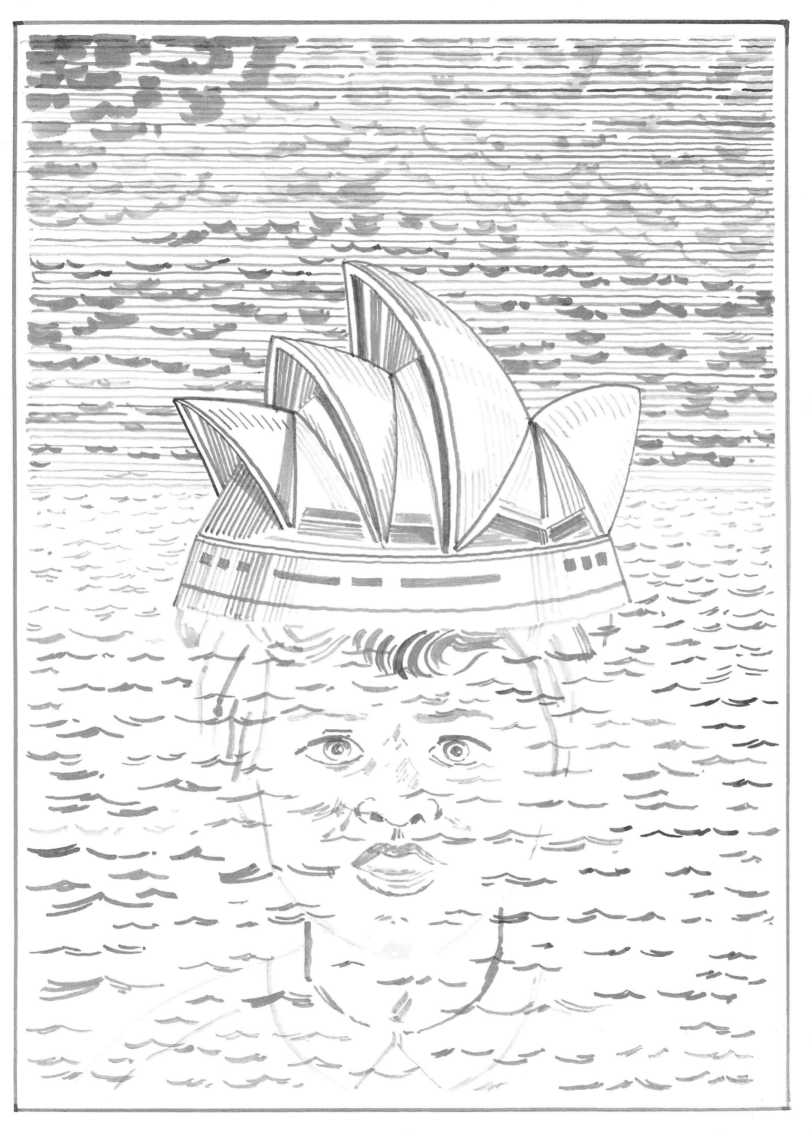

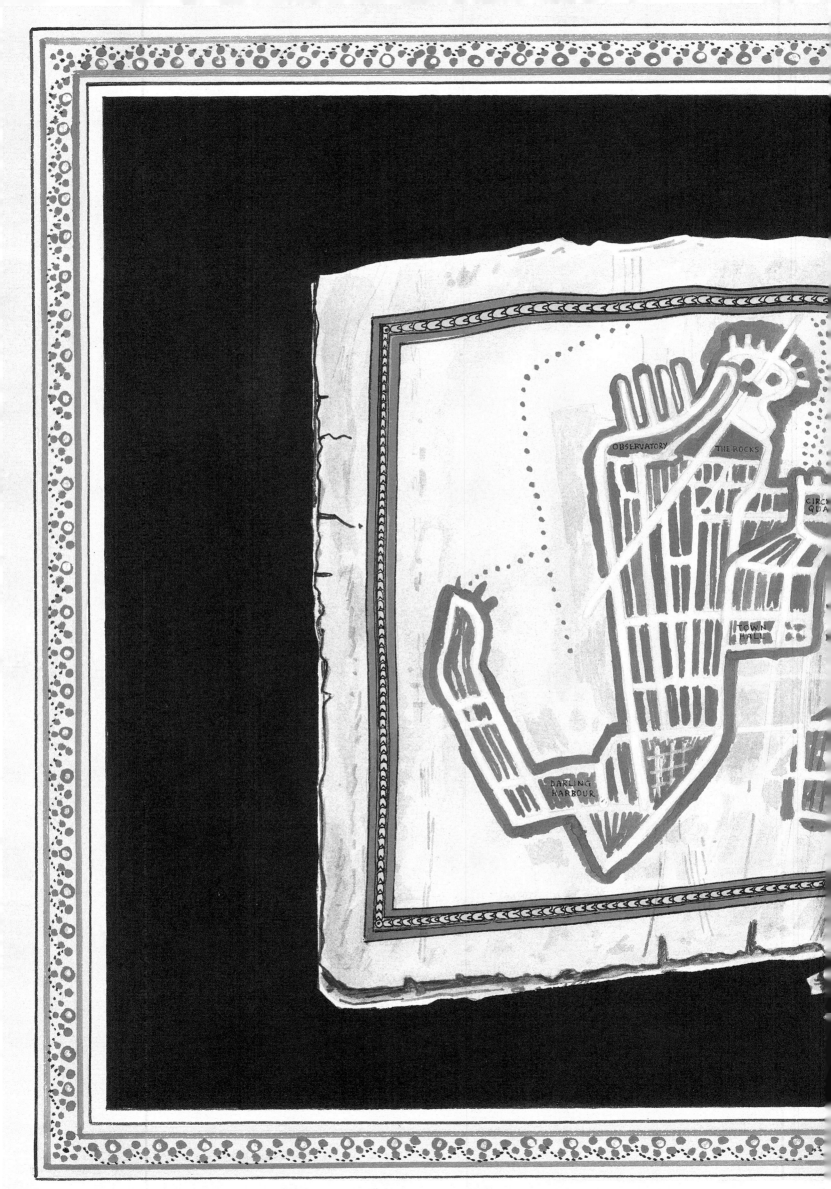

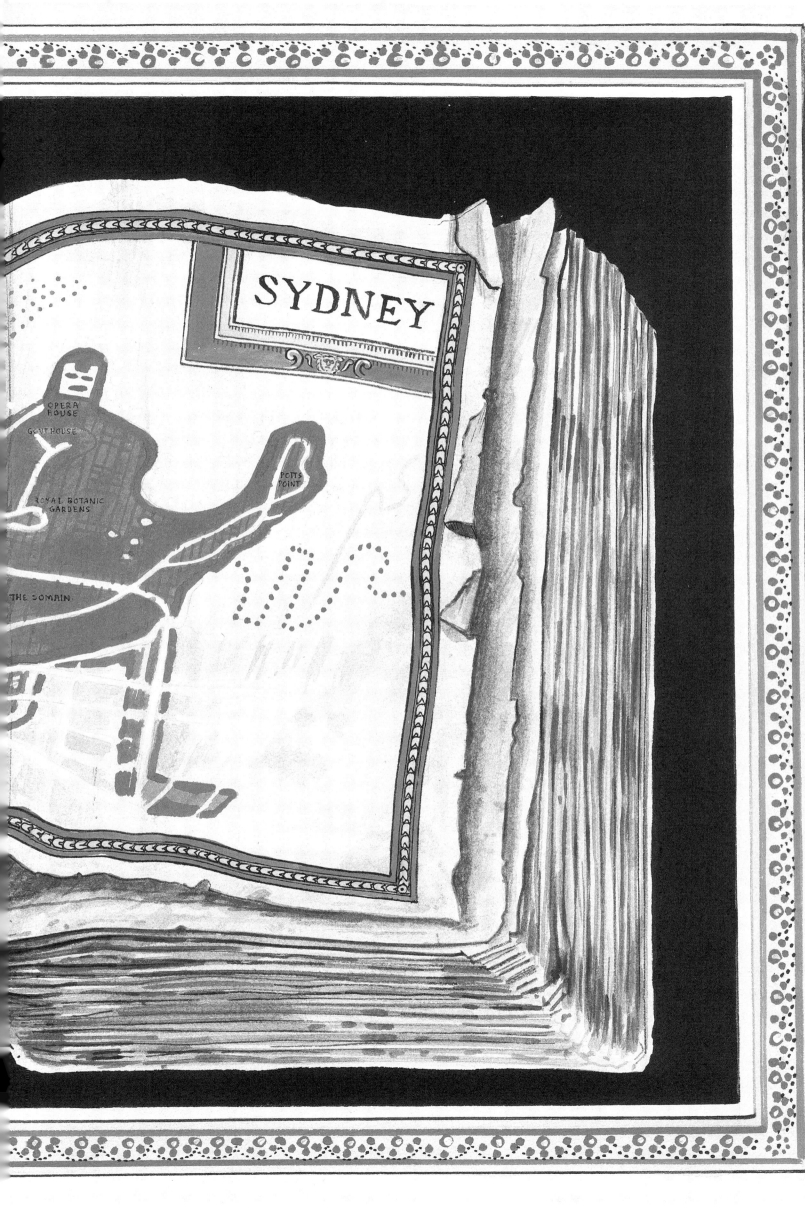

RIO DE JANEIRO
THE CITY'S PLUMAGE

Just as members of the animal kingdom are subject to certain innate behavior, strange ritualistic displays can also be observed in the conduct of cities.

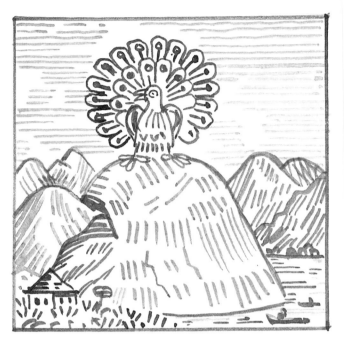

Cities might exhibit such behavior for the same ends as those of the smallest butterfly or the largest parrot.

What a city might be attempting to communicate through such 'peacocking' could be a form of courtship or, conversely, a warning display for the benefit of competitors and predators.

Just as when the circus comes to town with color, razzmatazz, and excitement, the alluring displays of such cities may sweep us along, but we oft end up held captive in an eternity of sweeping up elephant dung.

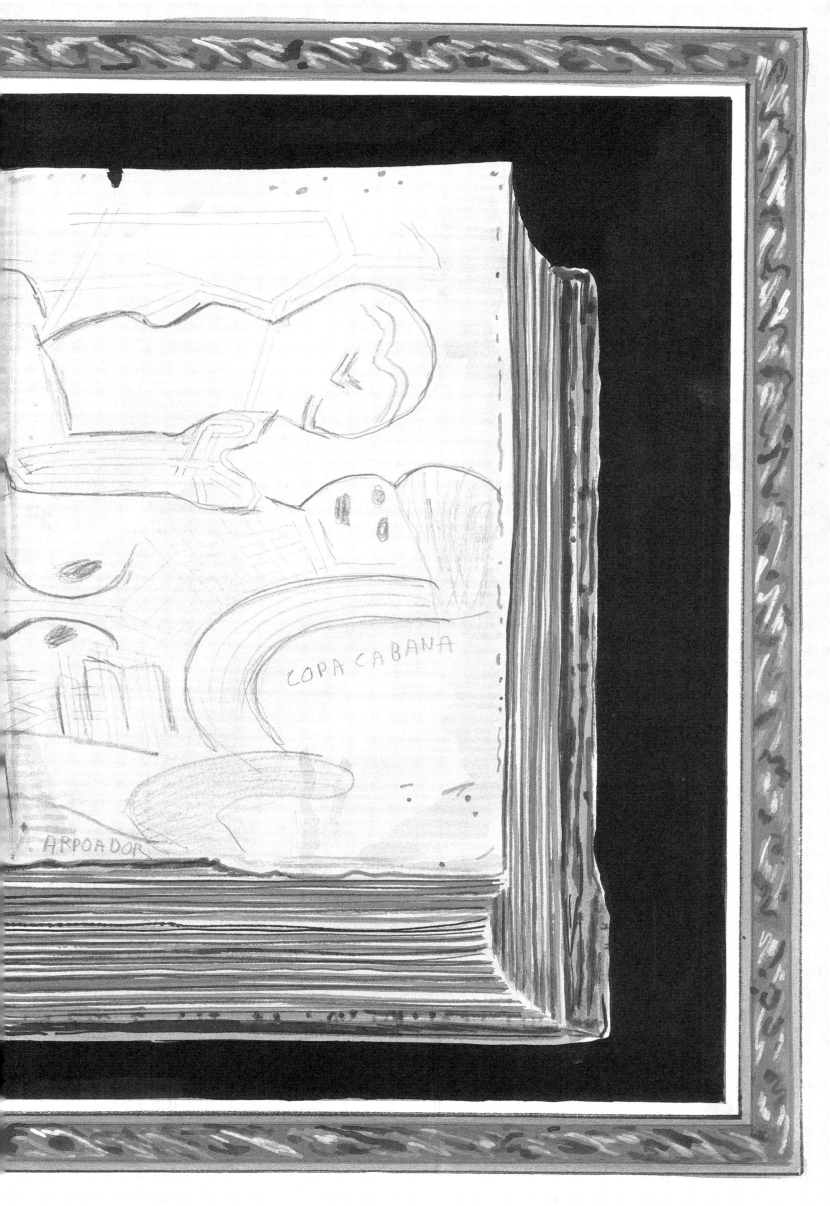

BOSTON
A CITY RE-PERSONIFIED

Some cities have found themselves re-personified simply by being the place where a fuse is lit to ignite a process of explosive transformation.

For these cities, this revolutionary process might involve loss of limb, withdrawal of regular nourishment and supplies, and other physical deformities caused by consequent punishment and privation.

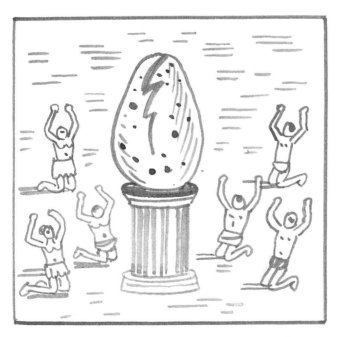

Such a transformation or emancipation is more than a throwing off of old clothes. It is a naked protest repurposed as a foundation myth for the city's new corpus.

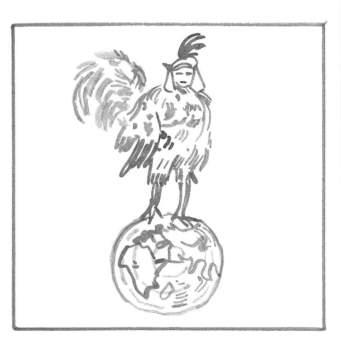

It is thus often the case that, when celebrating wars of independence, personal pride fashions the appearance of such cities, premising war-torn garb over official ceremonial dress.

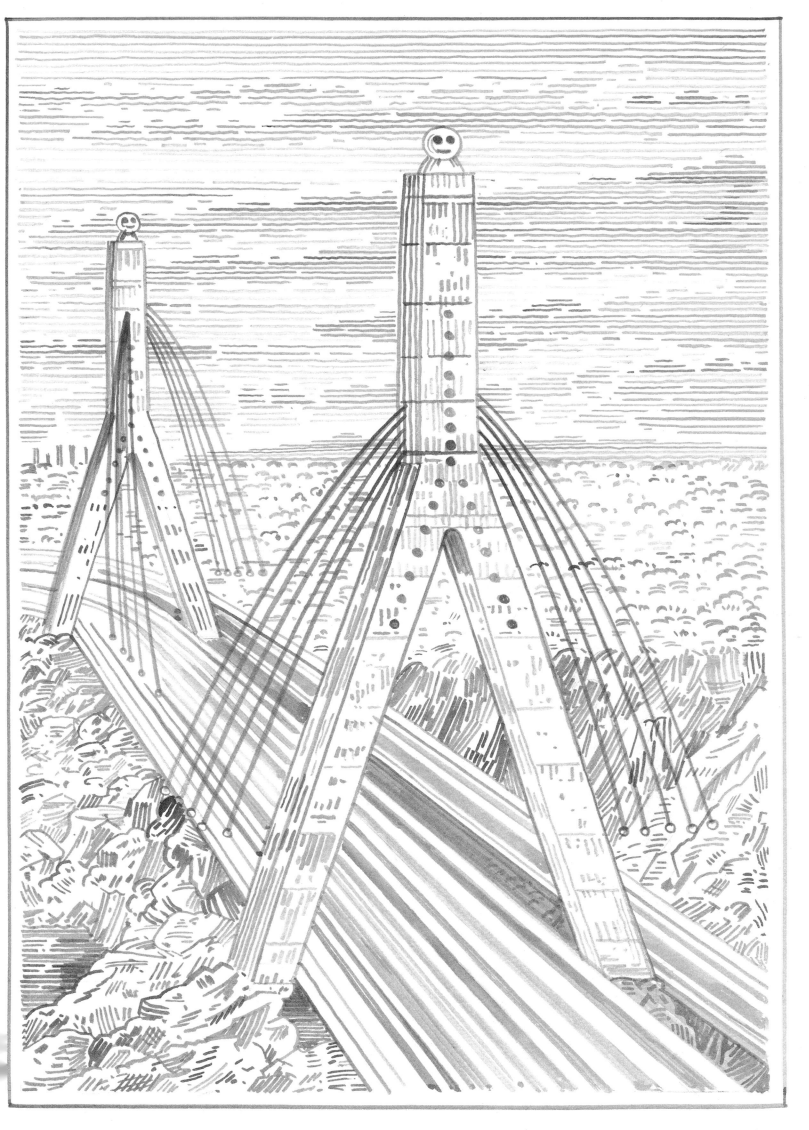

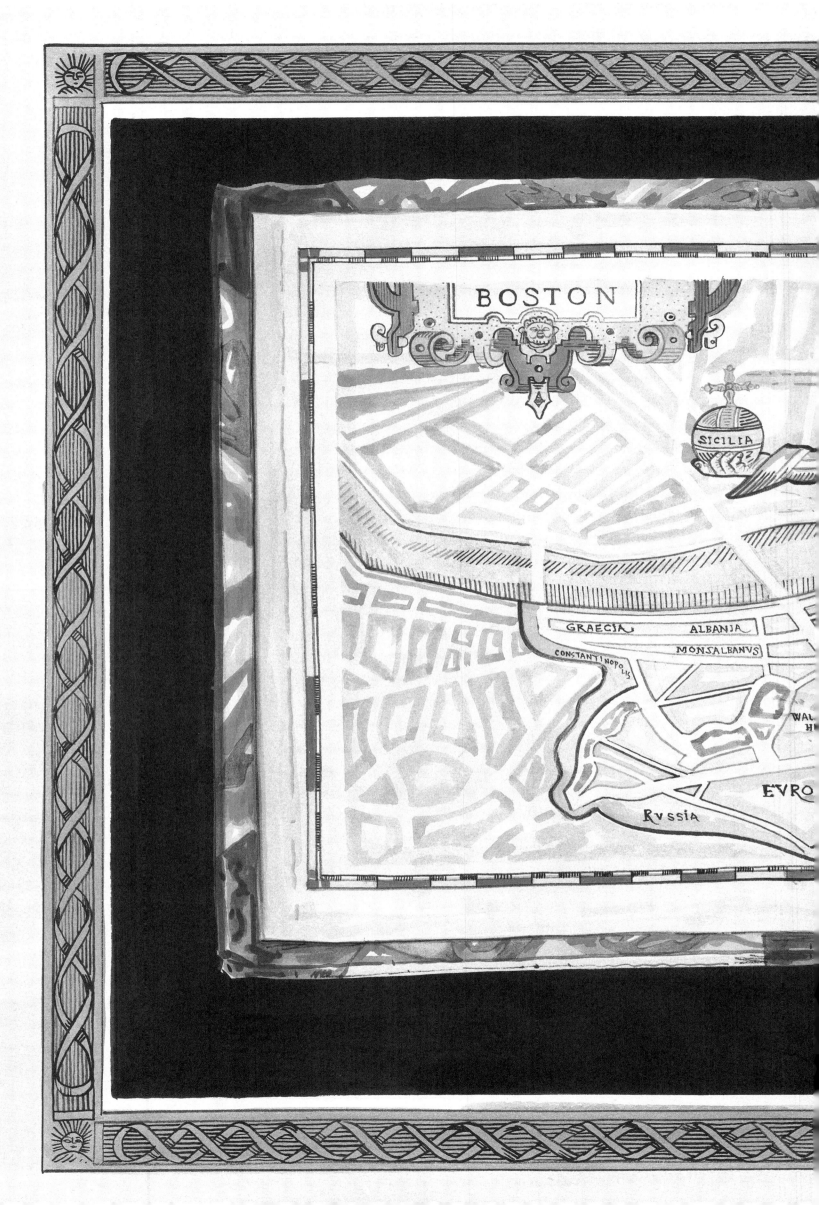

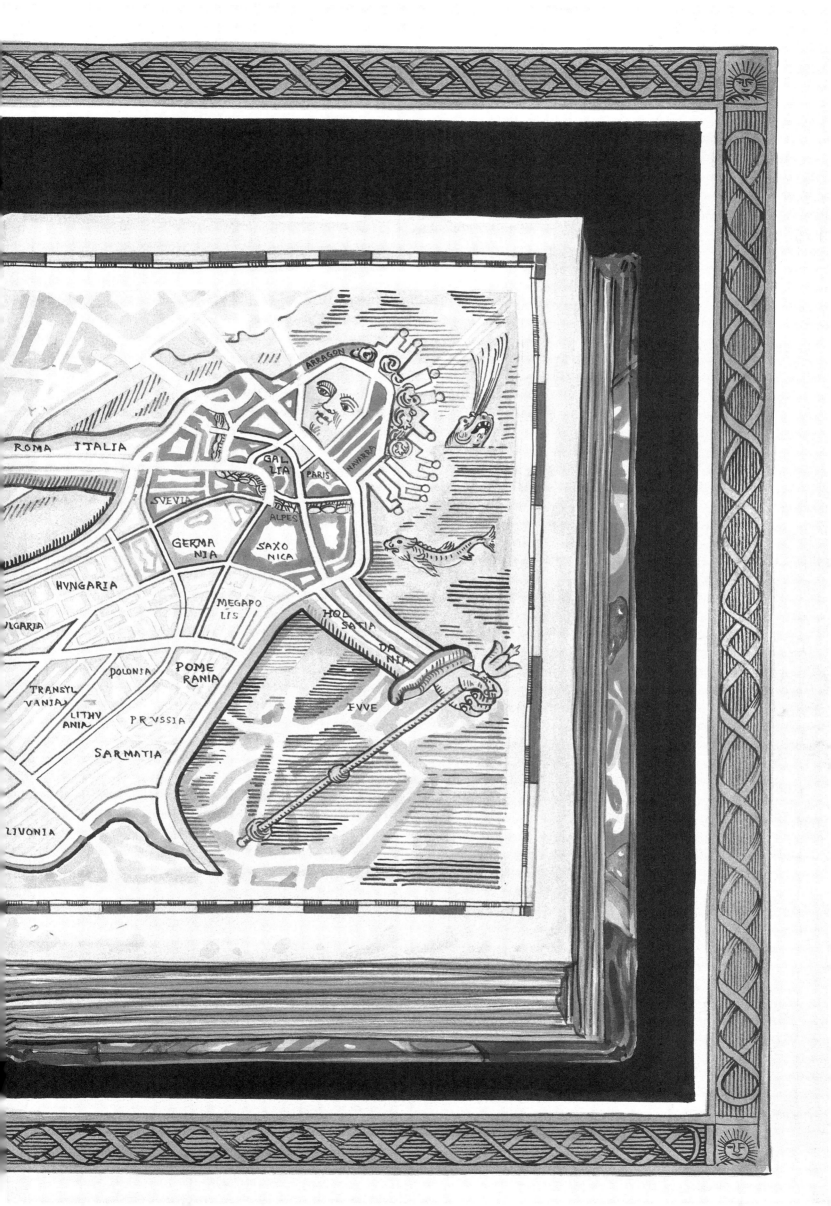

MANHATTAN
THE CITY DISSECTED

Manhattan flexes its muscles as the greatest city in the world, the ultimate embodiment of Gotham itself, a taut, buff, urban colossus. But sometimes the fate of the "supercity" is to end up being treated like a curious medical specimen rather than a sexy athletic titan.

A grueling life of groundbreaking performances leads a rapt audience to wonder from whence such dizzying feats spring. The curious spectators prod and probe the perfectly honed body of the supercity in search of the source of its magical power.

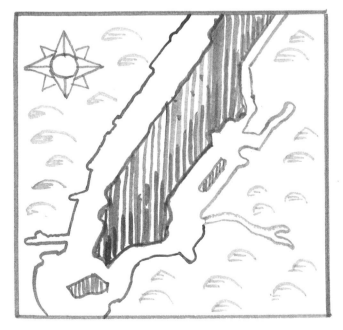

Its musculature is stretched to breaking point, its nerves are tested to extremes, and its architecture is torn down and flung up repeatedly by both the adoring crowd (in incredulous worship) and jealous detractors (in vengeful destruction).

As scientists, historians, and general gawkers dissect and schematically map out the cadaver of the greatest city in the world, the wonder of seeing its construction revealed layer by layer almost compensates for the fact that it is condemned to end up "on the slab" as a breathless pile of concrete and steel.

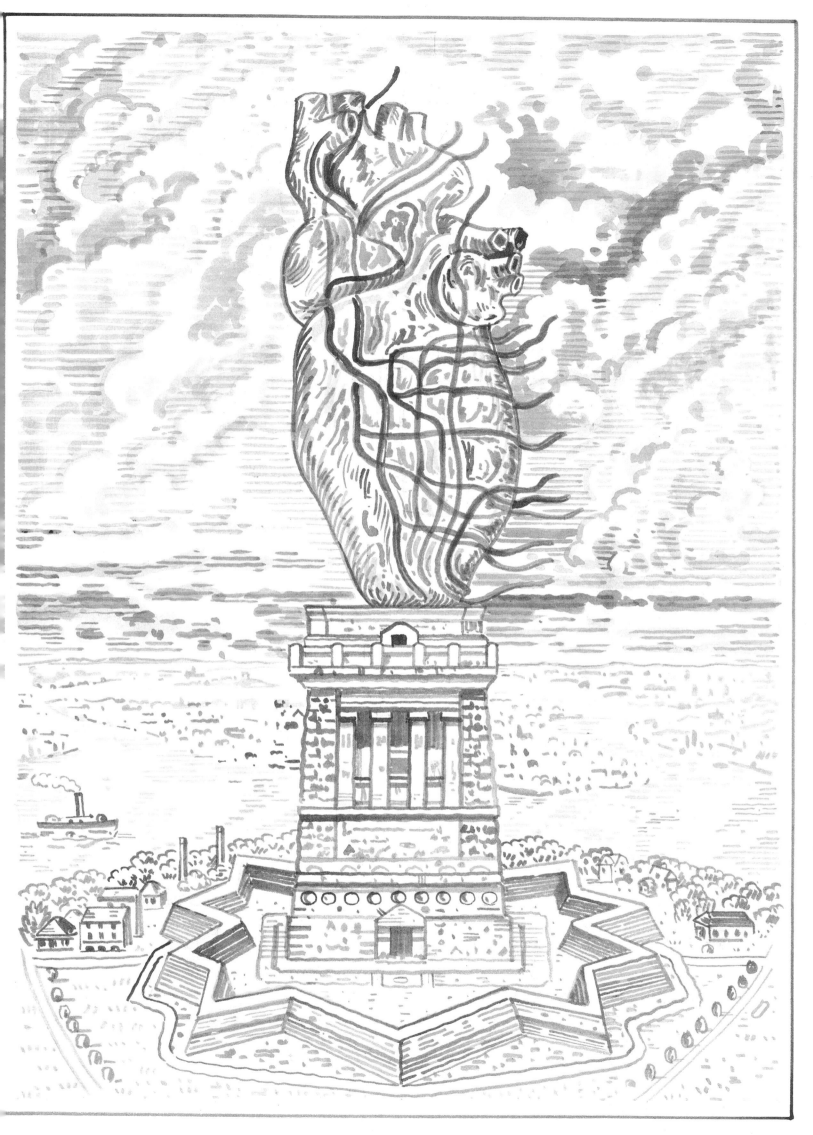

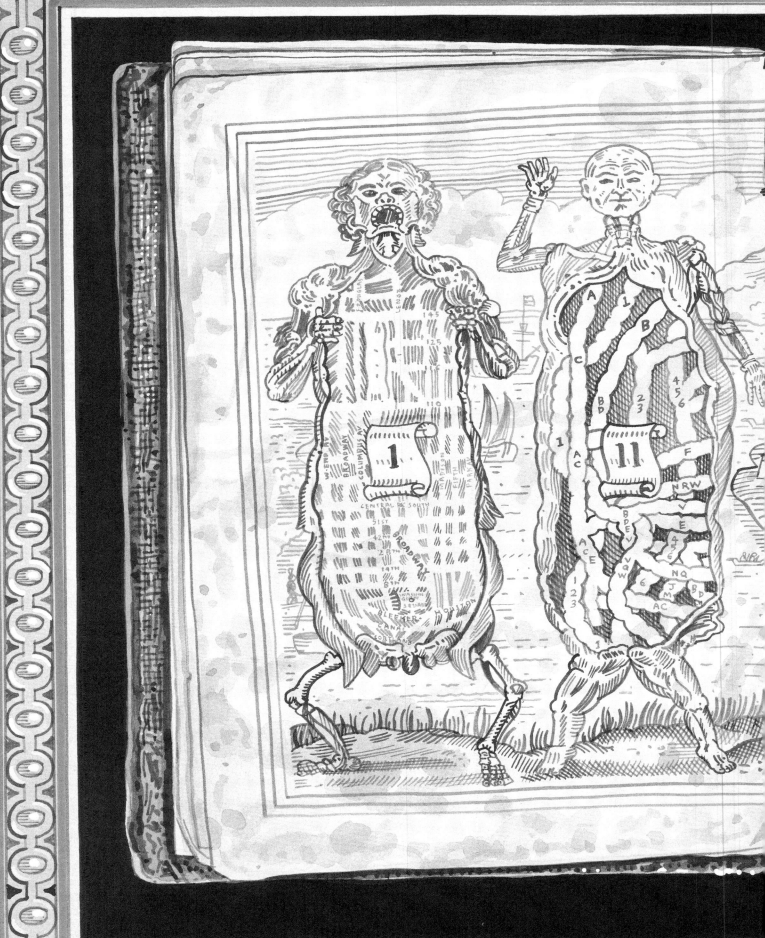

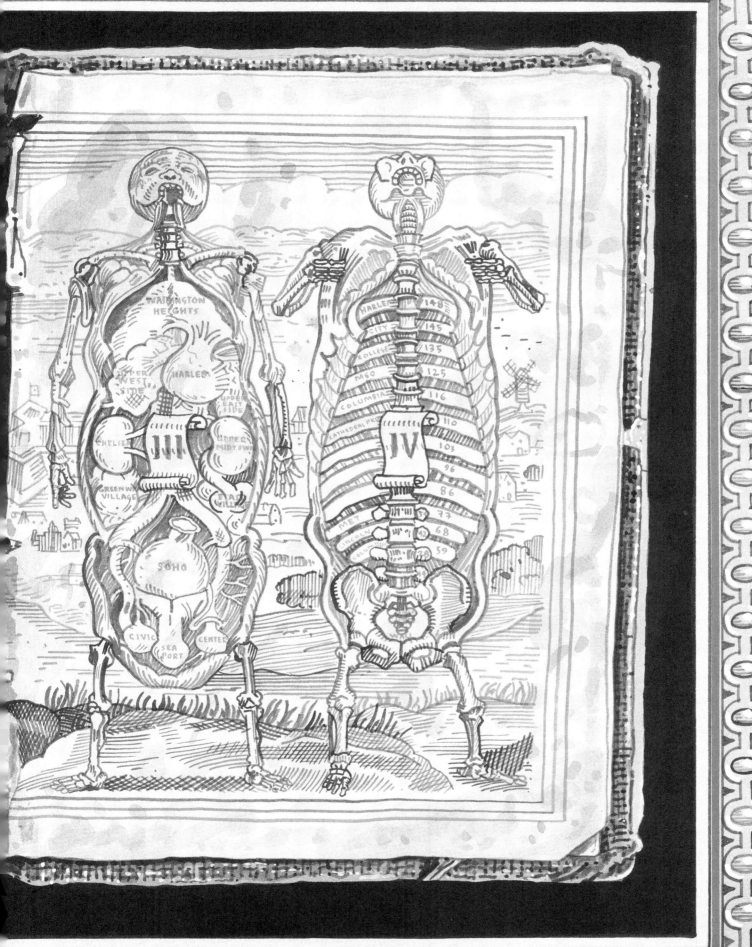

CHICAGO

THE CITY AS EXEMPLAR

In growth, structure, and construction, the pioneering characteristics that set the modern city apart are calculated to act as a beacon for others.

This city's eye-catching characteristics, being of the new model rather than forms rehashed from the classical ilk, are full of excitement and purpose.

Will a city that exists to spawn a host of imitations be held responsible for any of the less than successful versions of itself?

It is more likely that a successful manifestation of the new model city will eventually be classed in the same order as those places that the pioneering city had sought to supplant.

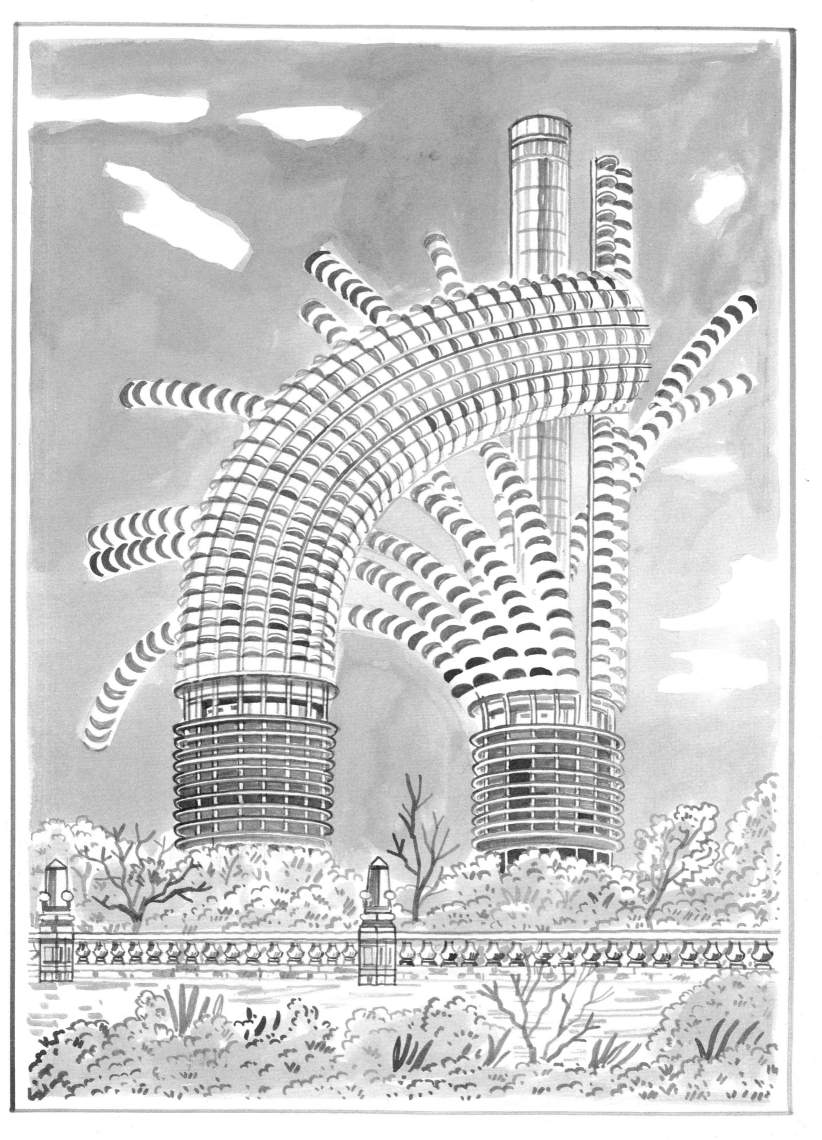

A PLAN VIEW OF CHICAGO

NEW ORLEANS

THE CITY DEFYING THE CLOCK

The truly nocturnal city, one whose breath and pulse are only noticeable in the hours of darkness, could be seen as defying both the spinning globe and changing time zones.

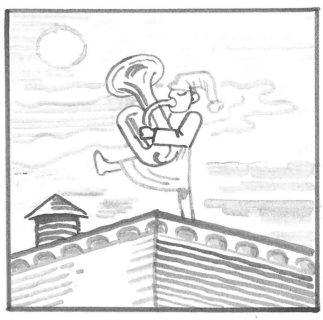

By choosing to live apart from its neighbors, finding kinship instead with places on the opposite side of the earth, the nocturnal city exists in a state of peculiar geographic somnolence.

Such a city does not disappear during daylight hours. It continues to exist, but in a dormant state, readying itself for a public appearance, or resting after one.

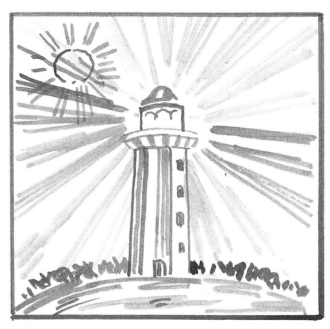

The usual world order, in the case of nocturnal cities, might only be restored when their geographical opposites also opt to exist primarily at night.

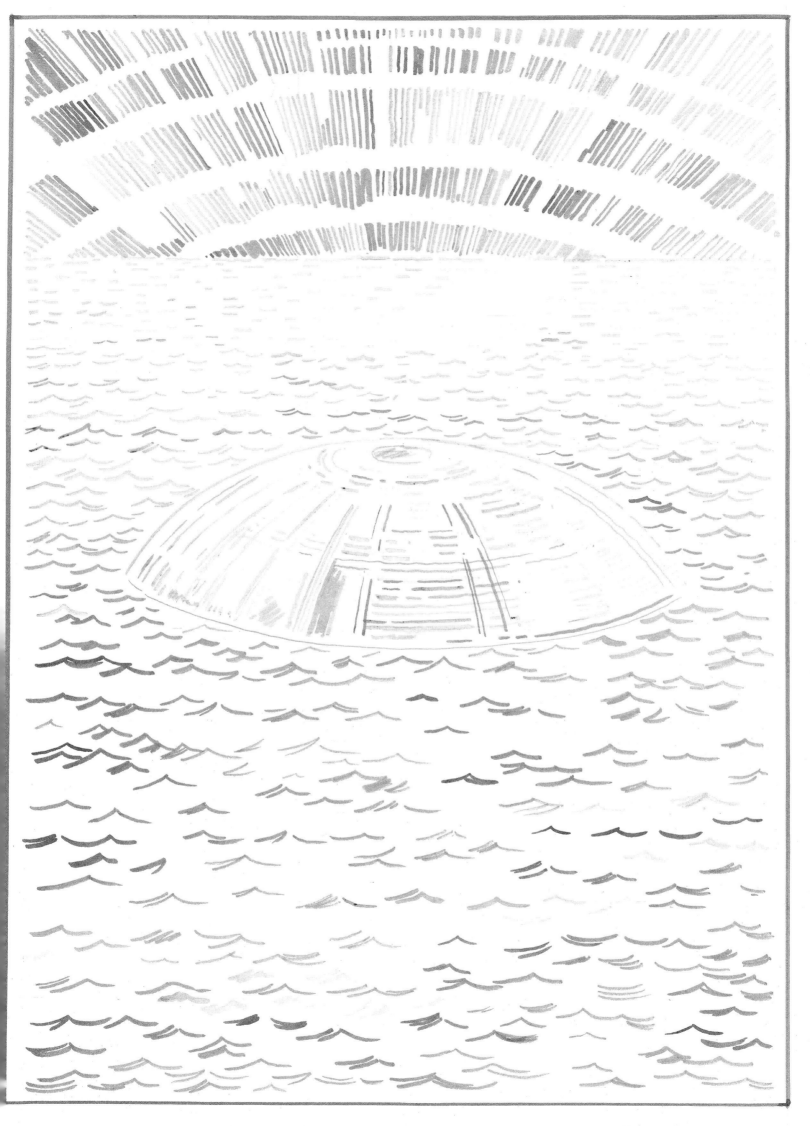

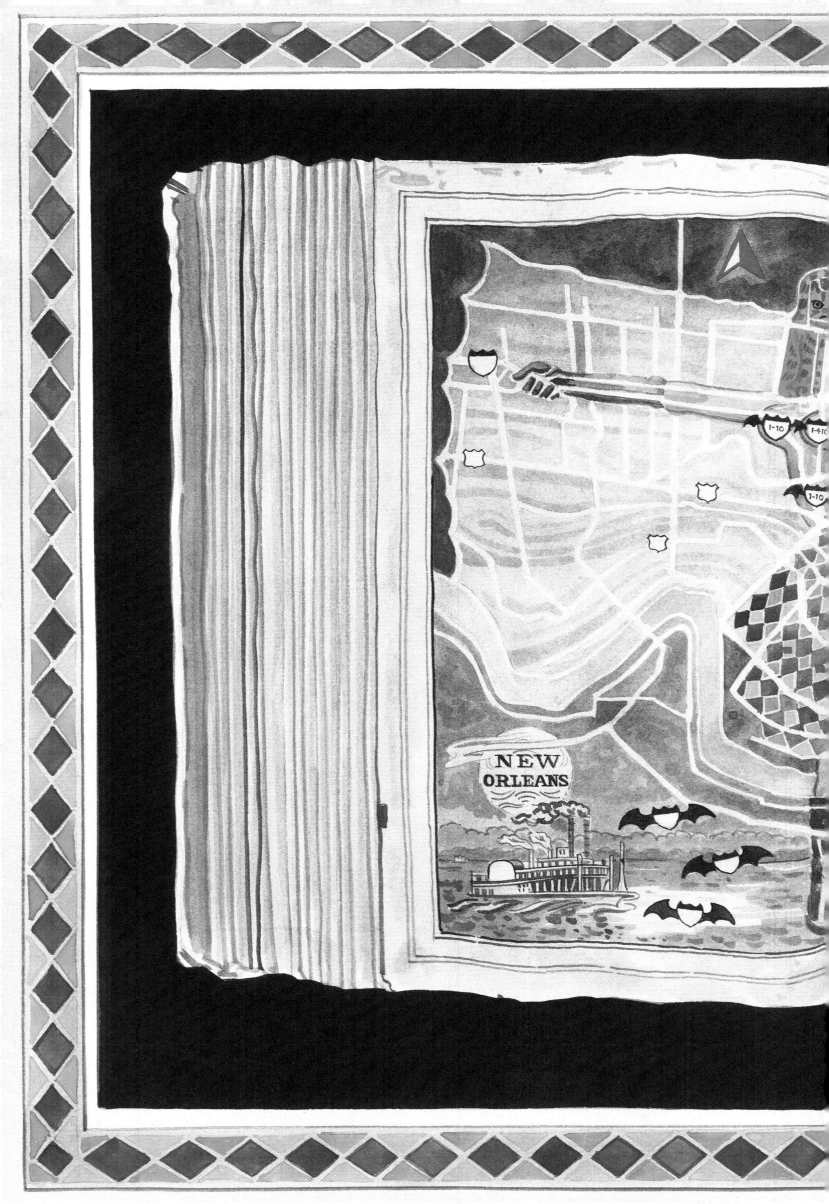

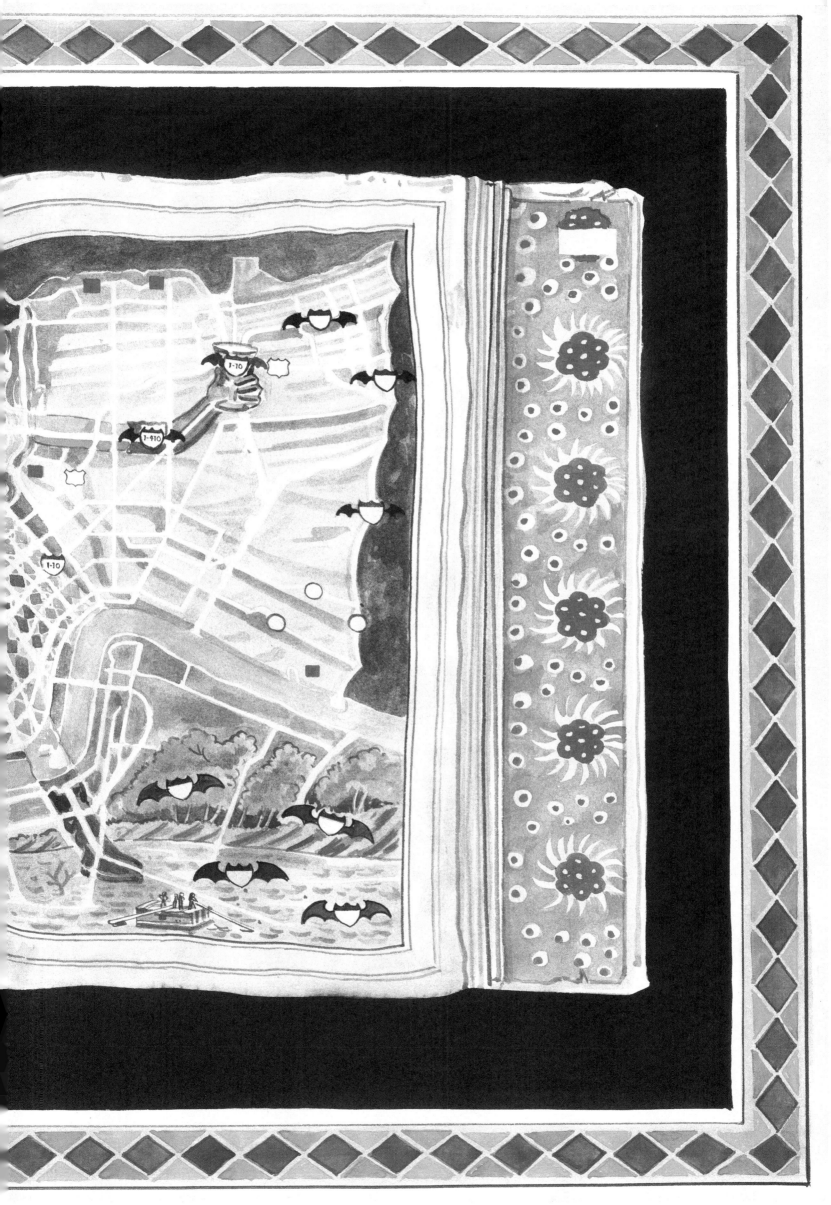

DALLAS AND FORT WORTH

CITIES BORN ACCIDENTALLY ON PURPOSE

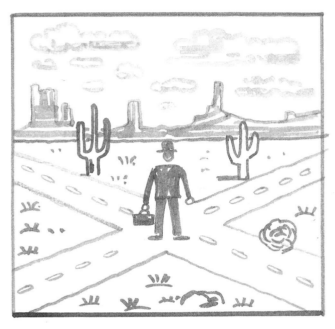

Cities between cities or cities in the wilderness, brought into being for their own sake, often have to create their own modus vivendi from nothing.

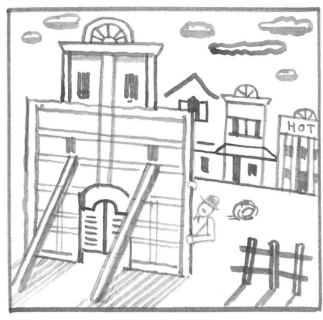

Part of the process of self-identification for the "stranger city" involves the promotion of a personal mythology that is as vivid in presenting what is known as it is in obscuring what is not.

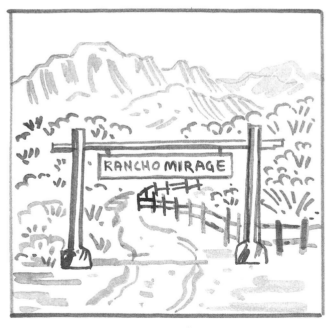

Personified, these cities might be encountered as if "stepping out of the mist" or "appearing from nowhere" in the midst of a barren landscape.

They might also depart in a similar way, such as by "riding into the sunset."

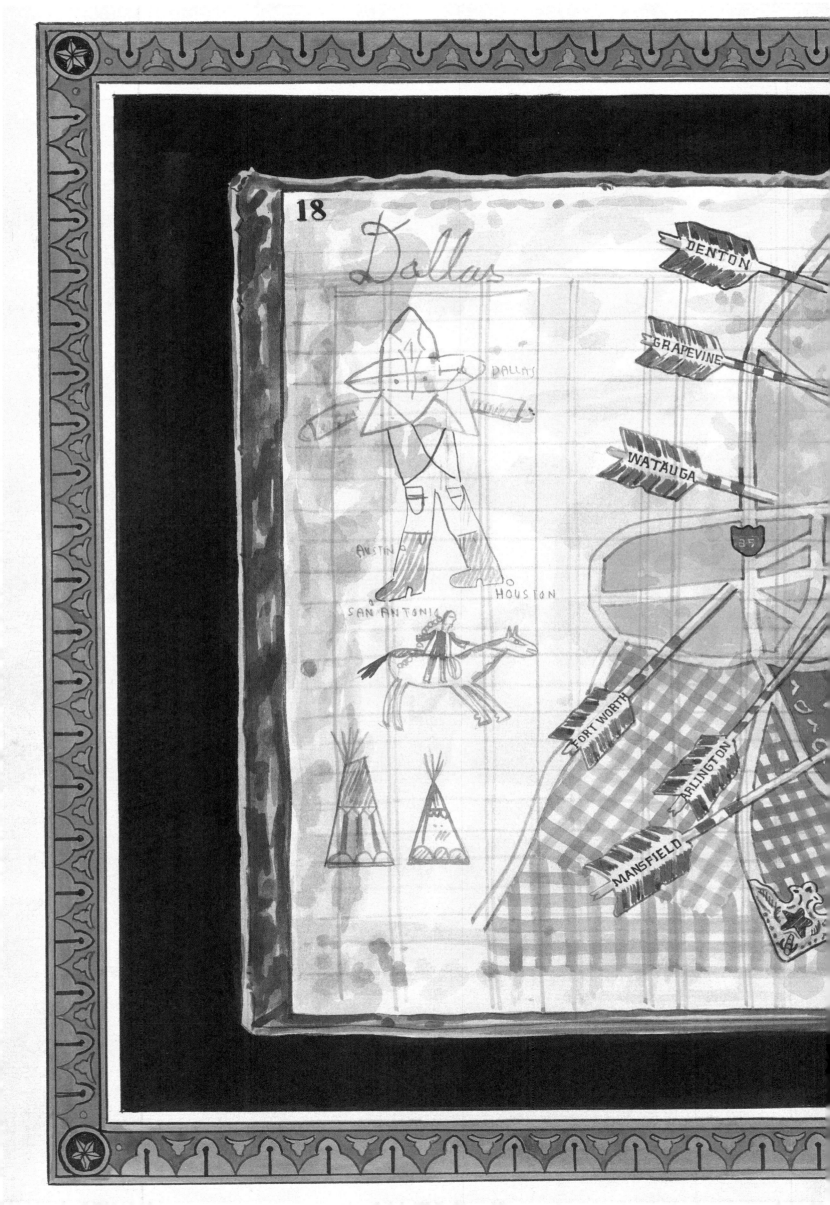

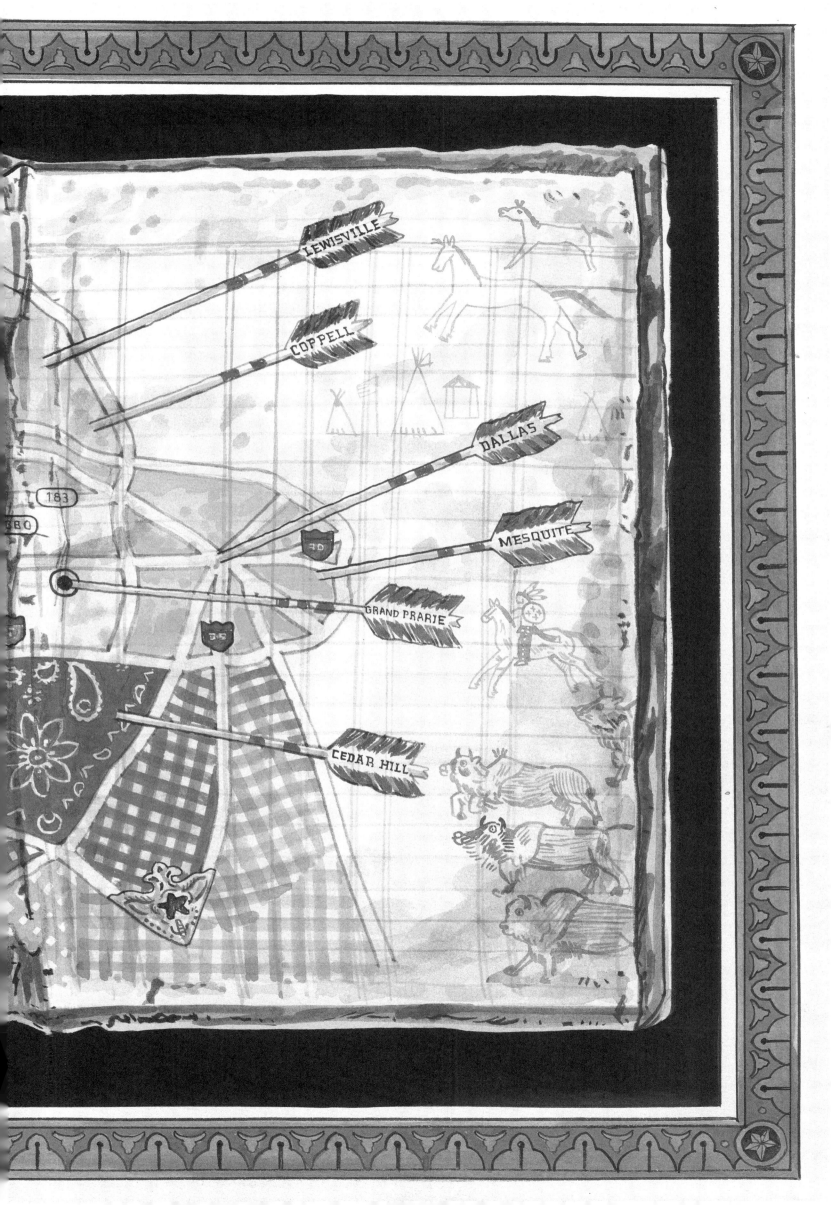

SAN FRANCISCO
THE CITY REJECTS THE CITY

For a city to drop out of the status quo and tune itself into an alternative wavelength might imply that it has turned on its residents, challenging them to step up to a problematic utopian proposition.

A process of rebirth or reimagining often involves some kind of regression, stripping down, or disintegration. This does not at first bode well for a city, the personification of which, under such circumstances, may start to appear a bit hairy.

The positing of a counter truth as to what a city should be, whilst appearing idealistic and inclusive, is often taken as an antagonistic gesture in the midst of well-regulated daily life.

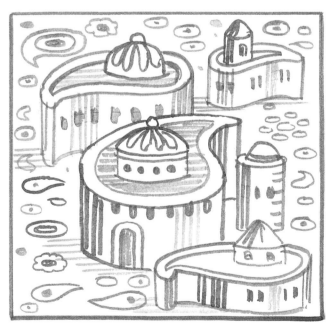

How long a city re-personified by such a trope can remain apart from the established order is contingent on how attractive it is "post-operation," and how its appearance and trappings stand the test of time.

SAN F

CISCO

LOS ANGELES

THE CITY AS PHANTOM

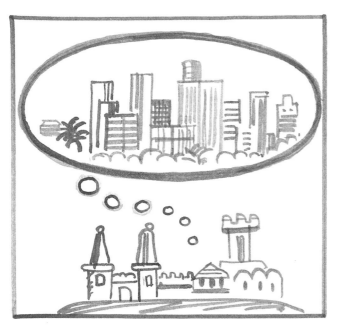

As in fictional genres where the fantastical stands in for the real and the reader is asked to suspend their disbelief, so a city might be personified as existing beyond the real.

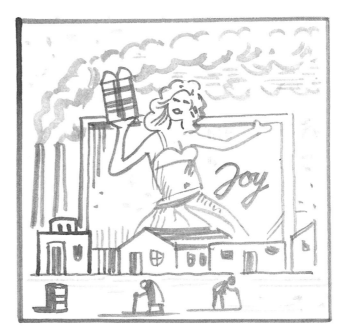

The effectiveness of exercises in Cartesian skepticism — or a desire to question the real appearance of things — is contingent on the particular allure of the alternative spectral presence.

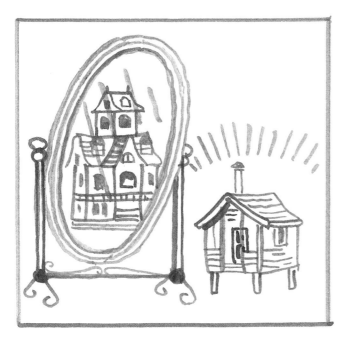

That the city as a phantom or apparition might represent a preferable or deeper reality gives form to the notion that we are all not who we are supposed to be.

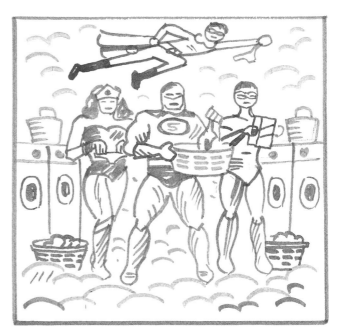

As this far more desirable reality gradually separates itself from the quotidian practicalities of trips to the laundromat, shaving, taking out the trash, etc., the city as an angel, a reflection of our "real" reality, inevitably becomes one with a dirty face.

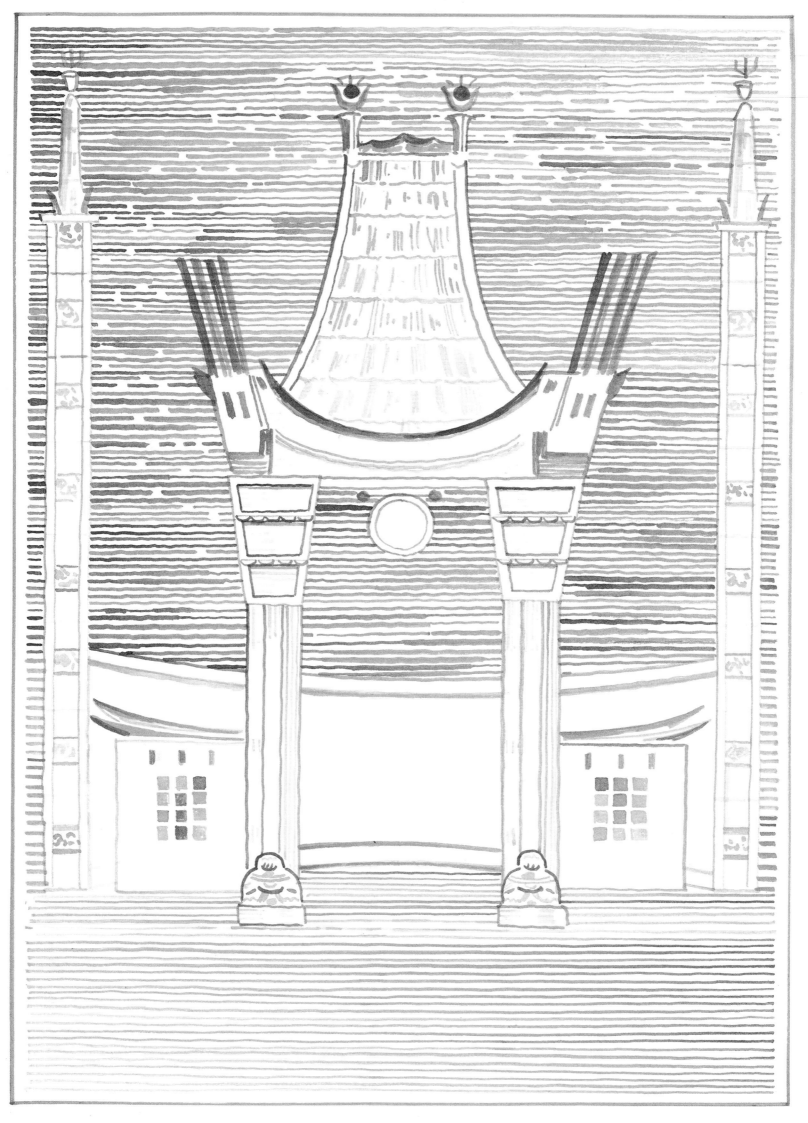

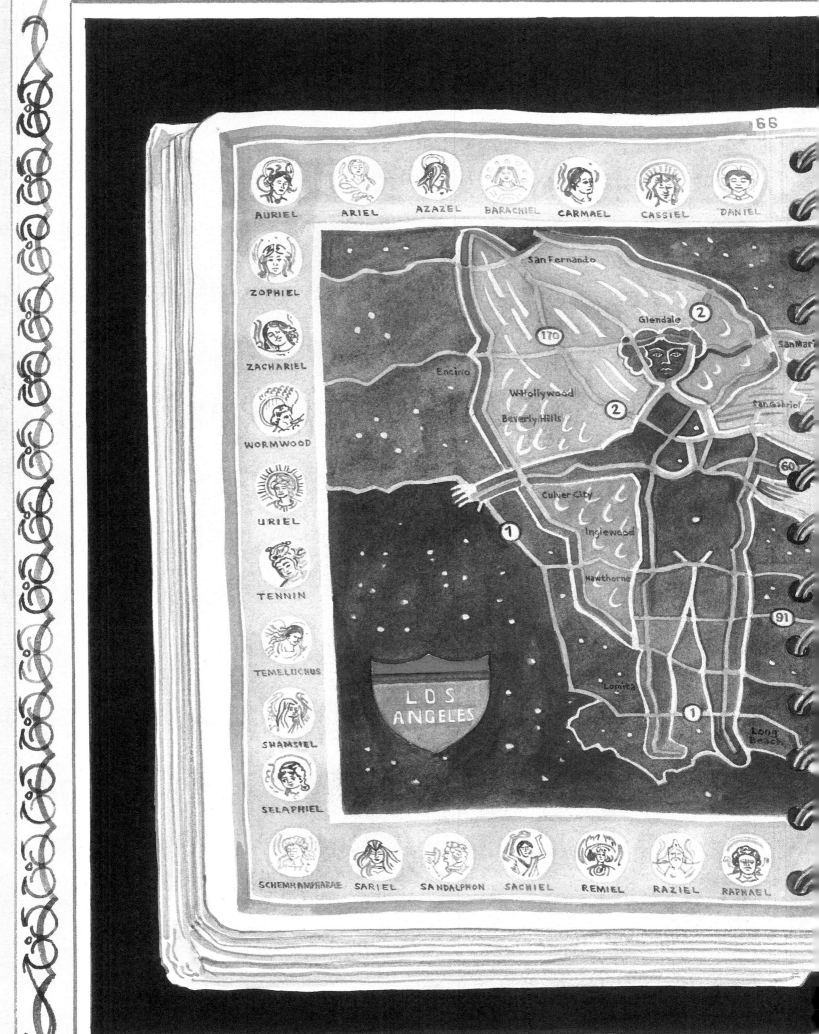

DUMAH EREMIEL GABRIEL GRIGORI HADRANIEL HANIEL HARUT

JEQUN

JERAHMEEL

JOPHIEL

KUSHIEL

LEILIEL

LUCIFER

METRATRON

MICHAEL

57

Ontario

Pomona

60

Chino

60

71

57

La Mirada

Fullerton

91

91

Anaheim

241

55

22

261

Irvine

City of Industry

ANGELES

FOUNDED 1781

errirce

RAGUEL QAPHSIEL PURIEL PHANUEL PAHALIAH NETZACH MURIEL

DUBAI
A CITY OF VISITORS

The personality of a city that has been constructed by people from one place for the benefit of people from another is, like its artifice, a plastic import.

The faces of such cities are cosmetic in the extreme, with features honed to reflect a reality devoid of any inheritance or familial duty, the epitome of the metropolitan norm.

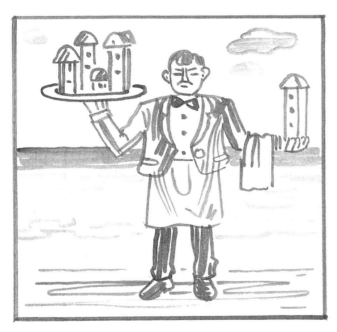

In servicing its imported populace and adapting itself to their requirements, the "person" of such a city becomes defined by the whims and fancies of the visitor, its bearing and status that of a borrowed retainer.

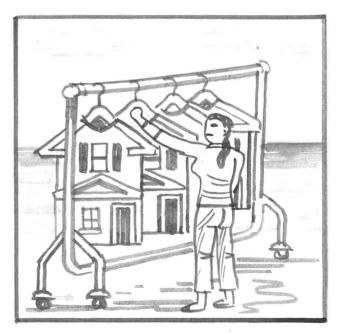

The identity and livery of a city that exists in a state of perpetual rotating indentured servitude is thus entirely contingent on the quality of the imagination of whoever happens to be handing out orders and uniforms at any given time.

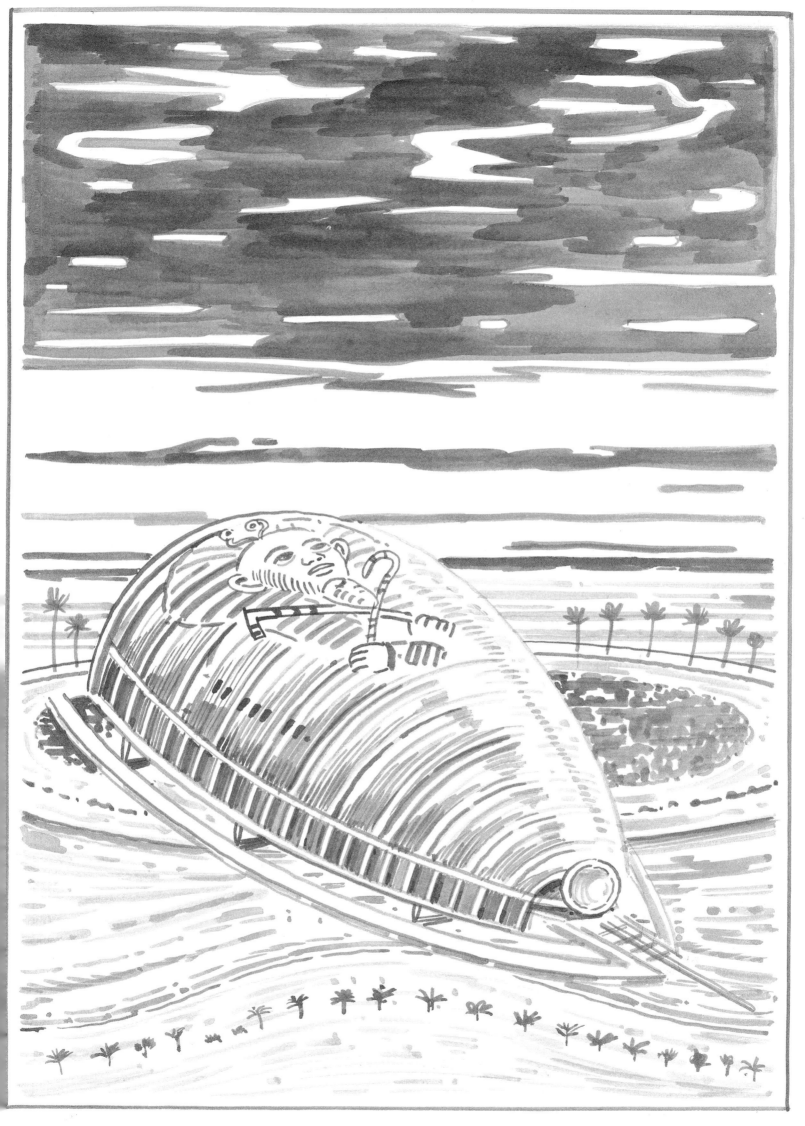

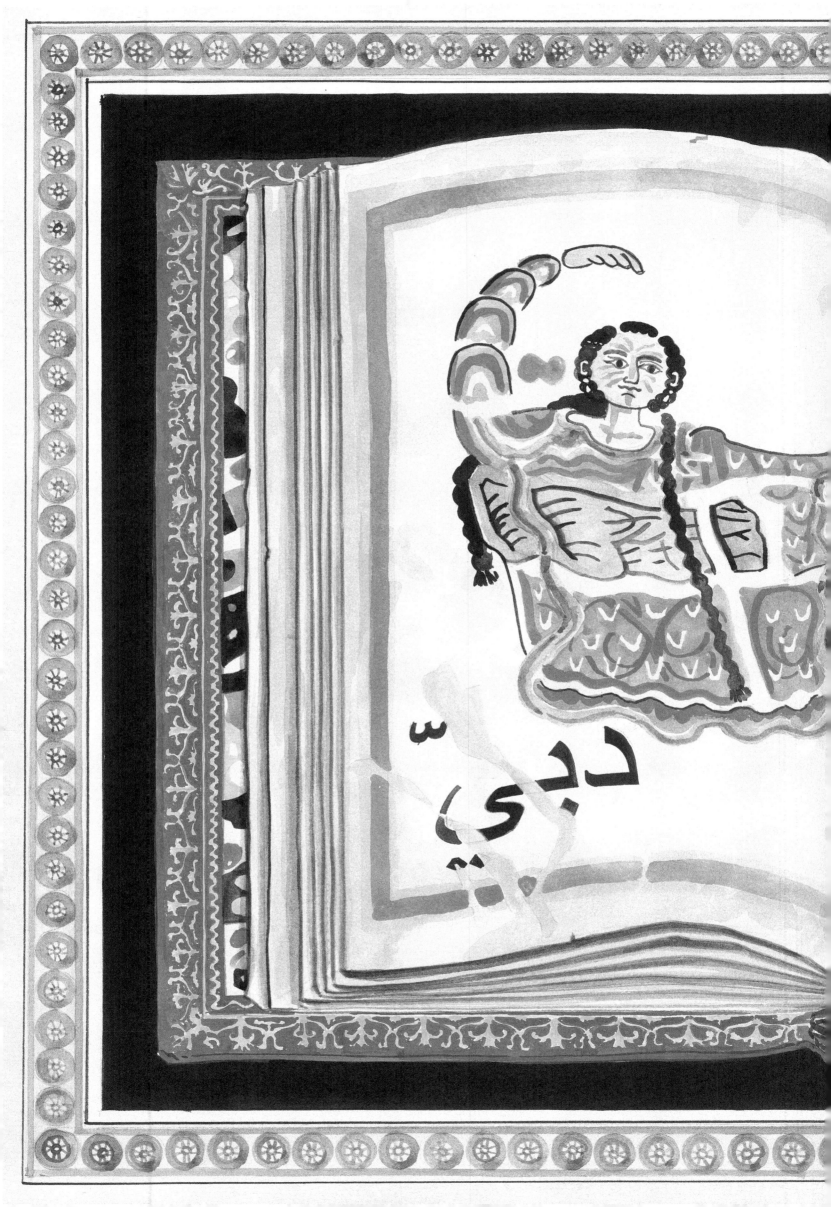

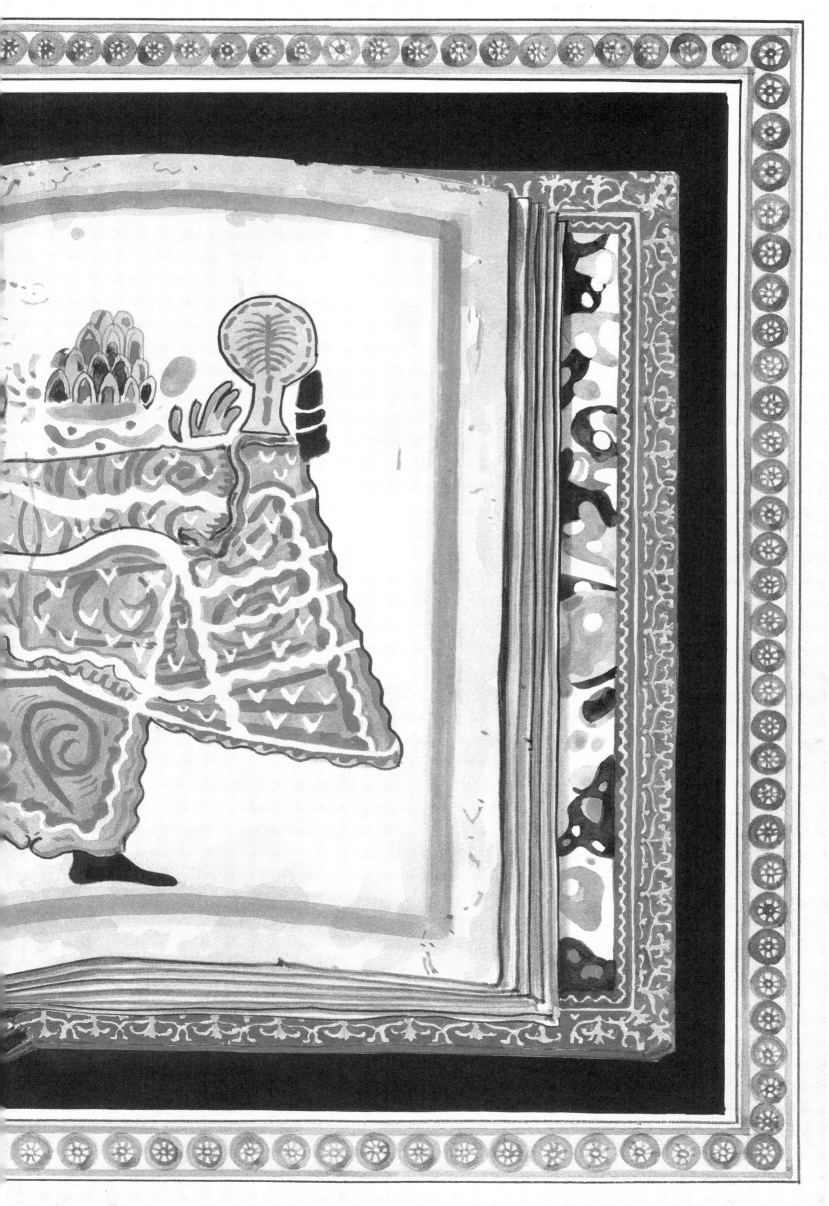

ACKNOWLEDGMENTS

Special thanks in the production of this volume go to Melissa and Grace, and to the eponymous and elusive Dr. London.

Repro of certain images by Simon Heath at Online Repro and Danny Smalls at Metro Imaging, London.

Photography of Venice and Edinburgh maps by Jeremy Freedman.